GW00777593

DOULTON STUDIO NOTES

a Miscellany of Amateur Contributions.

1883-1887

SELECTED BY
PETER ROSE

Richard Dennis
2007

ACKNOWLEDGEMENTS

Firstly, my thanks must go to Desmond Eyles, the chronicler of Royal Doulton who, in a series of splendid works, published over many years the fruits of a lifetime of research into the history of that great company. Desmond died in 1987, but had devoted his last years to collecting, analysing and transcribing the volumes of *Studio Notes* which he had gradually assembled from all over the world. All those latter-day disciples, including the present writer, who benefited from his diligence, owe a great debt of gratitude to him for his openness and willingness to share his research discoveries with them. It was a common understanding between all those involved in Doulton scholarship, that Desmond's culminating triumph would be a publication based on the *Notes*. After his death his widow, Olive, provided Richard Dennis and myself with the surviving papers and notes, together with the dozen or so volumes of *Studio Notes* which Desmond had gathered together. We all hoped that, after minor tidying and editing, the fruits of his last labours would be published. Sadly, this proved not to be possible and the present volume represents a more practical concept: that I would make straightforward selections from the *Studio Notes* and accompany each of these facsimiles with a brief contextual note.

The publisher and author wish to thank all those who have helped in this compilation. We owe a great deal to the late Desmond Eyles and his widow, Olive. We thank the many others who have contributed so willingly to the task of discovery, sifting and further research, including Paul Atterbury, Albert Gallichan, Louise Irvine, Jocelyn Lukins, the Misses Mott and the Royal Doulton Archive assistants and last, but not least, my editor Sue Evans.

Peter Rose, Brighton, 2007

Editing and production by Sue Evans
Photography by Magnus Dennis
Print and reproduction by Flaydemouse, Yeovil, Somerset
Published by Richard Dennis, The Old Chapel,
Shepton Beauchamp, Somerset TA19 OLE
© 2007 Richard Dennis and Peter Rose
ISBN 978 0 903685 02 3

A frontispiece from Studio Notes

Contents

FOREWORD

Thirty years ago I was employed at the Victoria and Albert Museum to research 'The Doulton Story' exhibition and my fascination for Doulton wares continues unabated to this day. For me, part of the ongoing attraction has been discovering more about the personalities behind the pots and the *Studio Notes* has provided many insights into the varied characters who contributed to the success of the Doulton Pottery in Lambeth.

Each new detail gleaned about the Doulton artists in the *Studio Notes* enables me to flesh out their personalities and helps bring them to life. The opinions expressed in their writings and the activities enjoyed in their spare time add to my enjoyment of their work. I look at their Doulton designs with new eyes having seen the sketches they produced on their holidays or heard of the places they visited to study their subject matter. I love the image of Florence Barlow dismissing a critic at the Crystal Palace Bird Show and her sister Hannah being jostled by piglets on a Surrey farm as she tried to draw them.

It's hard to imagine what the *Studio Notes* would have been like without the contributions of the female artists but the initial plan for this 'manuscript magazine' in November 1883 was that it should be 'supported by and circulated amongst the male Artists and Assistants'. Although the female artists had already celebrated their 10-year anniversary at the Lambeth Art Pottery, they were not to be included in 'The Sociable' – one of the suggested names for the miscellany. Fortunately this changed after just seven volumes and a New Series, heralding contributions from the ladies, began in May 1885. Now subscribers could also enjoy the sketches of Ada Dennis, Eliza Simmance and Florence Lewis alongside articles by Mark V. Marshall, Arthur Pearce and others.

Readers couldn't dwell too long over the *Studio Notes*. Each subscriber in a pre-determined circulation list paid one penny to read the volume for one day and they were fined another penny if it was returned late. By the Third Series the subscription had increased to three pennies and members who did not contribute literary or artistic subject matter had to pay double.

I was first introduced to the *Studio Notes* when I began work in the Royal Doulton archives where two volumes are lodged (First series, Volume 3, April 1884 and Third Series, Volume 15, May 1892). Later, Desmond Eyles allowed me to study the volumes he had assembled from former Doulton employees. Some volumes were beyond my immediate reach, having travelled far across the world to Australia and then on to the United States as they were handed down through the family of William Rowe. Apparently, on the death of the first editor, Walter Gandy, his sister Anne sent 30 volumes of the *Studio Notes* back to the Lambeth factory for distribution amongst the old artists and pensioners. Harry Simeon chose four volumes in 1939 and these were sold at auction nearly 60 years later by his daughters.

With all these volumes in private hands, few collectors have been able to appreciate the delights of the *Studio Notes* so we are greatly indebted to Peter Rose for selecting some of the highlights for this book. Peter's extensive knowledge of nineteenth-century design history, and Royal Doulton in particular, make him the perfect person to interpret the *Notes*. He has taken this miscellany of amateur contributions and placed them authoritatively in their Doulton context, as well as giving them a wider social and historical perspective.

We are extremely grateful to Richard Dennis, who has been a dedicated guardian of this precious source material for many years and has greatly added to our knowledge and understanding of the Doulton Lambeth Wares with his exhibitions and publications.

Louise Irvine, 2007

DESIGN IN BEAUTY by Peter Rose

Jottings from Journals by Doulton Artists 1883-1887

> 'The Lady Artists and Assistants now engaged in the studios upon
> the work desire to take this opportunity of expressing our obligation
> to you for the origination of an occupation at once interesting and
> elevating to so large a number of our sex.'

The lady artists and their assistants had seized the opportunity,
ten years after the inauguration of the Art Studios at the pottery
works of Henry Doulton at Lambeth, to address their employer
in gratitude for an extraordinary act of artistic and social
patronage.

This contented, fulfilled and highly talented community of
over two hundred women and a much smaller group of a dozen
or so men, enjoyed a working environment so unusually benign
as to be in many respects unique in the pottery world, perhaps
in industry generally, in late nineteenth-century England.

The exquisitely illuminated presentation volume containing
the address had incorporated on the title page, a drawing of the
palatial new premises of Messrs Doulton & Co. on the Thames
river front at Lambeth, flanked by two semi-nude female figures
displaying finely proportioned vases. These ladies surmounted
an elaborate architectural structure carrying a trophy of assorted
Doulton pottery, which also sported in panelled reserves the
proud declaration 'Design in Beauty' and 'Build in Truth'

From the rich variety of educational and social opportunities
provided by work and leisure, emerged an enchanting flowering
of amateur talent in the form of a regular series of manuscript
compilations entitled *Studio Notes*. These were an early example
of a house magazine, but organised and written by the employees,
reflecting every facet of their work and leisure. Out of the forty
or so volumes painstakingly assembled over a period of ten years,
from 1883 to 1892, almost half have been traced, although
scattered worldwide. The present work comprises a selection
made from the ten surviving volumes covering the first half of

the decade of production; however, a chronological order has not been followed. A selection from the equally rich second half will possibly form a future publication. Despite the determination to encourage the employment of women, a disproportionately large number were employed as junior assistants engaged in the more mundane ancillary tasks. These employees, like the numerous men engaged in the clay preparation and pot-throwing workshops, were not participants in the *Studio Notes*, which confined its circle to the senior artists.

The story of how Henry Doulton came to be such a benevolent progenitor of the many thousands of pieces of art pottery which collectors across the world now treasure, will be familiar to many and perhaps deserves more attention than is possible in the brief outline provided in this general introduction. However, one of the extracts selected from the *Studio Notes* written by Wilton P. Rix, the first Director at the Lambeth Pottery, describes some of the background in lively detail (see page 81).

Henry Doulton's father, John, had gone into partnership with John Watts in 1820, forming the company Doulton & Watts, Lambeth Pottery, London. They prospered, mainly in the traditional lines of salt-glazed utilitarian ware; bottles, filters and the like. However, the rapid expansion and industrialisation of the metropolis created an urgent need to dispose hygienically of the noxious effluent created by all that teeming activity. Salt-glazed drainpipes linked to pumping stations straddling the Thames were the chosen and effective system, which survives after a century and a half, to the present. Doulton's were the major suppliers of the piping and other sanitary equipment under the management of the young Henry Doulton who masterminded the enterprise. He had formed a separate company using his own name, which was so successful that eventually it came to dominate the whole family business.

The late forties and fifties, the period of most rapid expansion of the pottery trade, also saw the consolidation of a reforming movement in the field of design and in the encouragement of the Arts. The most spectacular demonstration of the new spirit was The Great Exhibition of 1851 which, to complete its full title, comprised the Works of Industry of All Nations:

it represented the fruits of a national struggle to improve the standard of design in manufactured goods. From the 1830s government committees and social reformers had investigated and reported on the lack of quality, originality, and honesty of purpose across the whole field of industrial design. Out of the ensuing debate emerged a network of Schools of Design designed to train young artisans to recognise and employ those qualities, which were deemed to be good and true.

Lambeth's turn to receive the attention of the design reformers came in 1854 when Canon Gregory founded a school to enable *'the parishioners of Lambeth to obtain an elementary knowledge of design'*. He and his advisors were fortunate to appoint John Sparkes, an outstanding, reforming educationalist, as Headmaster. The Lambeth School was typical of many in being primarily an evening institute, catering for young men serving apprenticeships, who were seeking training in draughtsmanship and such-like skills. Controversy raged throughout the century over what constituted an appropriate education for a craftsman-designer. A deep reservoir of misunderstanding muddied the waters, confusing the general academic needs of the aspiring artist with the more precise skills required of a draughtsman. This mix-up revealed itself most acutely over the vexed question of drawing from life, which was considered appropriate for an artist but not for a craftsman.

Fortunately for the parishioners of Lambeth, Sparkes was an enlightened and inspiring teacher who incorporated in his teaching the best of both types of approach. Gradually the reputation of his school attracted not just the apprentices for whom it was intended, but also a growing number of young ladies of a more exalted class. Usually they were in search of graceful accomplishments, but sometimes necessity required them to find a means of livelihood also. It was this particular circumstance, which helped to forge the extraordinary partnership between Sparkes and Henry Doulton.

It was not, however, initially the women's cause which formed the spearhead of the campaign by Sparkes to secure a closer link between his school and the local pottery trade, but Edward Cresy, a friend and business associate of Henry Doulton.

Sparkes himself had tried unsuccessfully to introduce the idea of establishing an 'art' studio to Henry Doulton, but had been rebuffed. Doulton, now approaching his fortieth year, although high-minded and increasingly interested in literature and the arts, was determined to preserve his hard-nosed business sense, which had yielded such rich financial rewards. However, Cresy, a founder of the Metropolitan Board of Works, was more persuasive and encouraged Henry Doulton to experiment with a semi-decorative object, a salt cellar modelled on an ancient Rhenish piece, which was included in the Doulton and Co. exhibit at the 1862 International Exhibition. This was a signal for Sparkes who, seeing it on display, decided to make a fresh approach with, this time, more positive results.

At the same time, Sparkes was nurturing the talent of George Tinworth, an immensely talented youth from a deprived family, for whom he wished to find employment. The opportunity came in 1866 and, with a fellow student, Tinworth became an employee of Doulton's and tentatively began to design and decorate stoneware vases as well as modelling large medallions in terracotta. Some of these were exhibited in Paris in 1867 to critical acclaim. Four years of development followed when, at the 1871 International Exhibition held at South Kensington, a group of about seventy pieces of decorative stoneware was shown which not only included pieces by Tinworth but also by a young woman artist, Hannah Barlow. These were received so favourably that Henry Doulton decided to develop the venture more fully. In 1873 special studios were created at Lambeth for the Art Pottery (as it was called) and many more of John Sparkes' pupils, both women and men, were recruited.

At this stage a strongly marked philosophy and unusually benign working practices were developed which distinguished the Lambeth venture from other semi-philanthropic pottery studios. From the start there was encouragement of individual creativity for a large proportion of the workers. Unlike the Minton's Kensington Gore Art Pottery, which had been developing at the same time, the designs on the pots were the direct, original work of the artist-decorator. At Minton's the decorators copied the design supplied by the Director,

W.S. Coleman, or by Henry Stacy Marks, and were allowed to perform only as skilled hands: this was in accordance with general practice throughout the pottery industry. At Doulton's each vase, jug or decorative object was a unique product, even a pair of vases had complementary rather than identical patterning.

As the number of employees increased, a certain rigidity of method crept in. A hierarchy of decorators, craftsmen and women was established with an 'Artist' head of a studio responsible for managing and apportioning work to senior and junior assistants. These auxiliaries were assigned the more routine decorative tasks such as beading or applying the coloured slip to the scratched design outline. Despite such constraints each assistant had a personal mark that was applied to the base of the finished work and, in the illuminated address already quoted, each was accorded space for their mark or initial and signature. Many, as their skills and experience increased, were promoted to higher status within the organisation, and clearly shared the sense of gratitude and fulfilment, which shines out of the writings in the *Studio Notes*.

The studio system, already described, had more directly deleterious consequences for the artistic quality of the pottery itself. This deterioration was evident to at least some of the employees, notably Mark Marshall who, in the third volume of *Studio Notes*, published a heartfelt cry for the old days of simple, direct work, in a poem entitled *Lambeth Laments* (see page 78). The usual way of separating the work of a major artist from a junior was to sub-divide or band the pot, assigning each section to a different hand. Inevitably there was a loss of overall coherence: a certain mechanical evenness of detail which to the contemporary eye, conscious of the freedom and dash of modern studio pottery, might appear too controlled. In contrast, the early pieces have a much greater unity and immediacy of impact.

Today we are far more familiar with the Studio mode of pottery production. The potter chooses the clay; prepares it; raises it on the wheel or models it; then decorates, glazes and fires it. For good measure, in all probability he or she also markets it. The Art

Pottery mode was nearer to the factory-based, mass-produced methods associated with china shop purchases, but with crucial differences. The clay was selected and prepared and then raised or moulded by a potter, who was invariably male and worked quite separately from the female employees. It was no doubt felt that the ladies needed their respectability protected against the rough and perhaps threatening behaviour of the manual workers. This division set limits on the interaction between the thrown shape and the decoration, for, although the clay had to be sufficiently soft to be incised with the inscribed line of the design, the usual patterning technique, the clay was already too hard to be shaped or modelled. A revealing difference is evident when the work of female and male decorators is compared, for it becomes clear that the men were not constrained in the same way, and consequently were able to manipulate the clay more freely and directly.

A similar division is apparent in the later stages of firing and marketing which were all handled, as in a straight factory production, by separate departments. The camaraderie, which underpins so many of the *Studio Notes* contributions, was largely confined to management, the artist decorators and, to some extent, their assistants. There is no evidence of participation by the manual workers, although many were consummately skilled craftsmen in their field. The only record of due acknowledgement to these worthy men is a scratched inscription to *Tom Ellis, Turner* and *Bill Speer, Burner*, on the base of an enormous commemorative jug by George Tinworth.

The decade between 1883 and 1893 covered by the *Studio Notes* was a pivotal time in British history, for the now urban society created by the Industrial Revolution discovered a conscience with dramatic effect on all aspects of life. Socialism challenged the whole basis of the class system, with William Morris and John Ruskin providing a powerful link between political and aesthetic reform. The population was growing with ever increasing rapidity, and general prosperity provided more jobs than ever before. On the other side of the coin however, poverty, squalor and prejudice raised fundamental moral issues, which increasingly occupied the thoughts and writings of artists

and social reformers. Perhaps for the first time, businessmen were pausing to take stock, recognising that Britain's position as the 'workshop of the world' was under challenge. Innovation was still seen as the key to continued success, but as always elusive and fitful in achievement.

The rapidly expanding Art Potteries chimed with the emerging Arts and Crafts movement in exploiting a novel post-industrial solution to the notorious divorce of the creative artist-designer from the making process. Increasingly, an educated, prosperous middle-class schooled in the teachings of Morris and Ruskin, and stimulated by the outrageous posturings of George Bernard Shaw and Oscar Wilde, decorated their homes with examples of the New Art.

In consequence, the eighties was a period of expansion and prosperity for Henry Doulton and his company. There were nevertheless, economic difficulties and constraints, which emerge in the editorial commentaries which intersperse the contributors' texts in *Studio Notes*. Doulton & Co. was hugely successful in the frequent trade fairs, where the displays of the firm's output were dominated by the Art Pottery productions. Major exhibition pieces produced by George Tinworth, the most illustrious of the several sculptor-potters to emerge from the movement, were critically acclaimed by the press and awarded prize medals by the juries. John Sparkes, by this time Headmaster of the Central Government School of Design, continued his influential advocacy of the Art Pottery in lectures and pamphlets. He also designed an ambitious domed pavilion in glazed Doulton ceramic for the International Health Exhibition in 1884. Henry Doulton himself remained in almost daily contact with the most favoured of his artist employees, particularly Tinworth and the Barlows, whom he appeared to regard more as family friends than employees – a view which they fully reciprocated. He had, however, by this time become a prominent public figure, delivering public lectures to learned societies and supporting philanthropic causes. In 1887 Queen Victoria rewarded him with a knighthood.

Sir Henry led an active life until his death in 1897 but, towards the end, there were reverses and rebellions in the workforce,

which must have soured his last years. A disastrous fire at the works at the end of 1888 brought out all that was best in him. The morning after the fire, standing amid the charred ruins of the pottery, tears of despair running down his cheeks and seeing the dejection of the workmen, he turned to his managers saying, '*Well, now what are we going to do? You must employ all these men, mind – all of them!*' In contrast, he dealt ruthlessly with a group of strikers who he considered had acted selfishly and disloyally, refusing to re-employ them after they had conceded defeat.

For the Barlow family, four members of whom had been employed by Henry Doulton, he was a beacon of benevolent patronage. Hannah and her younger sister Florence, both regular contributors to *Studio Notes*, were creatively engaged at Doulton's for the whole of their working lives. A third sister, Lucy, also worked as an assistant for a while before joining their spinster ménage as the housekeeper. Arthur Barlow, severely disabled as a child, was also employed in the seventies, until his illness and premature death. The Barlow family was a paradigm of the beneficial consequences of the Art Pottery enterprise. Their father had been a prosperous land-owning bank manager at Bishops' Stortford, whose early death had forced the grim reality of making a living on his gently-reared young family. Hannah, followed by her sisters and brother, moved to stay with friends in south London and attended John Sparkes' school at Lambeth. Hannah had great natural talent particularly in drawing animals, with which she had a great rapport. She briefly worked at the Minton's Art Pottery at Kensington Gore, (where she was already noted as a character, arriving for work with live mice in her pocket) before becoming the first female employee at Doulton's, working alongside Tinworth and her brother, Arthur, in the earliest days of the Art Pottery enterprise. It must have been an act of considerable kindness on the part of Henry Doulton to contrive successful working facilities for such extreme physical disablement as was suffered by the young Arthur. Today we require laws to make such provision, but it seems that a natural kindness, reinforced by Christian conscience, motivated this particular Victorian employer. Florence, like her sister, loved and studied the natural world

and, after a brief period when it was difficult to tell the sisters' styles apart, they reached an amicable agreement to split the terrestrial and celestial kingdoms: Hannah drew horses, goats, sheep etc., Florence drew birds, from the most domestic to the most exotic.

A growing distinction surrounded the leading artists in the Studios, particularly in the columns of the burgeoning women's magazines, which understandably were concerned mainly with the personalities and working conditions of the female employees. Illustrations of Hannah and Florence working in their shared studio appeared in *The Queen* in 1887: Hannah, a rather portly figure, seated and decorating a large cache-pot partly wrapped in her apron; Florence, slimmer and more smartly dressed, also seated and rather atypically modelling a group of small birds. The setting with a cloth-covered table, complete with a vase of flowers in the background, has a comfortable domestic air. The accompanying text refers to a *'recreation room with piano etc.,'* which was at the disposal of workers between the closing of the workrooms and the commencement of the evening sessions at the nearby Lambeth School of Design. Many of the Doulton ladies although fully employed, continued to study part time in order to improve their drawing skills. George Tinworth was however, the greatest celebrity, attracting a stream of visitors from royalty to archbishops, politicians and art critics. John Ruskin and Edmund Gosse were great admirers, the latter writing a biography and appreciation of the sculptor-potter to accompany a lavish catalogue published by the Fine Art Society. The occasion was an exhibition of Tinworth's sculptural works in 1883, which attracted much favourable press comment. The most ambitious religious pieces were not, however, a commercial success and later in the decade it became evident that the employment of a quirky, independently-minded religious fanatic was something of a loss-leader. It was estimated that the annual loss represented by the running of the Tinworth studio amounted to approximately £1,000. However, the publicity value was incalculable. Although there are fairly regular, somewhat arch references to the *'great man'* locked away in his own special studio, surrounded by his vast, unsold

religious works, Tinworth never made any direct contribution to *Studio Notes*, perhaps because he was barely literate.

To a somewhat lesser extent other Doulton characters caught the public's attention. Mark V. Marshall had joined the Studios on a freelance basis in the late seventies, having split up rather acrimoniously with the eccentric sculptor-potter Robert Wallace Martin and his brothers. He brought to Doulton's some of the oddity and vitality emanating from the partnership, and eventually surpassed all others in consummate originality and skill in modelling, decorating and colouring the pottery. Marshall was a regular contributor to *Studio Notes* with poems, articles and illustrations. Frank Butler, another original and prolific modeller, attracted public admiration and sympathy for triumphing over the distressing physical handicap of being deaf and mute – another example of Henry Doulton's concern to help the disadvantaged. But, throughout, the main recipients of this enlightened enterprise were the several hundred ladies who owed to him their *'interesting and elevating'* occupation, a proportion of whom regularly contributed to *Studio Notes*.

The first issue of *Studio Notes* appeared in December 1883; and for several years the editor was Walter Gandy, a gifted musician and water colourist. Although he designed and decorated pots, Gandy's role was concerned more with cataloguing and architectural design work, rather than practical decoration. He was a scholarly man who exercised firm editorial control over the contributors to the *Notes*. The very first, from Mark Marshall, *The Thing of Beauty*, is a curiously boisterous discourse on the themes of death, hunger and love: the text is re-presented by Gandy in his own impeccable copperplate hand. It was apparently accompanied by a poem of *'remarkable power and beauty'*, which the editor, with an executioner's stroke delivered with a velvet glove, decided not to publish *'in accordance with the too-modest request of the poet'*. Gandy could not resist exercising his editorial powers and showing off his own sense of superiority in ways which the more sensitive would find discouraging. However, his colleagues were robust enough not to be deterred, at least initially.

A footnote to a poem, *The New Wares* by 'Tom' declares:

'*The Editor does not vouch for the correctness of the assertions on the above lines and begs to point out to the author that there are two syllables too many in 3rd, 4th and 6th lines of last stanza.*'

His schoolmasterish proclivities move into top gear when reviewing a 'private' exhibition of the most interesting specimens of stoneware and faience turned out by Doulton's in the previous six months. Gandy declares that '*many errors of judgement and taste need attention*'; in the Doulton Ware there was a '*want of fitness of design*'. The ornament on the dessert services was '*much over-loaded for the purpose and the general requirements of such articles quite lost sight of in all cases by the designer*', and, finally, he advises his colleagues to '*aim at simplicity of design and... avoid over profuse decoration*'. Fortunately, Gandy allowed his lighter side to emerge and *The Troubles of Sketcher* by Percy Kemp (see page 125) is accompanied by several pages of vigorous and amusing black and white sketches.

The *Studio Notes* were precursors of the factory and office 'house magazine' which became ubiquitous in the twentieth century. They comprised manuscript compilations of between one and two hundred pages, and were bound between hardboards and passed around the contributors and, no doubt, to others interested, every two months or so; although later, the interval between the issues became longer and somewhat irregular. The contents are a delight to the eye: elaborately decorated title pages; delicate watercolours; humorous verses; philosophising tracts; architectural guides; holiday journals; competitions; regular pieces about the Studios, and the familiar chit-chat and scandal inseparable from any happy working community. The selection reflects many of these facets and catches the authentic flavour of the intimate and varied life of those relatively ordinary working folk who strive for excellence but are usually fated to be passed over and ignored in the historical record. The present volume of selected pieces allows us to enter into the private lives and adventures of these working men and women, capturing the flavour of their experiences and values to an extraordinarily intimate degree.

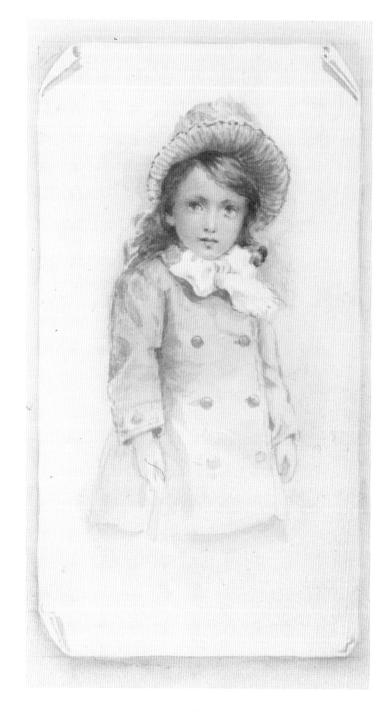

A Portrait
Ada Dennis (fl. 1881-1894)

The sensitive portrait of a young girl by Ada Dennis opposite appeared in the June 1887 issue of *Studio Notes*, together with another piece *In the Garden* reproduced on page 67. Like its companion it demonstrates her facility for achieving delicate and charming effects. The watercolour shown overleaf, also titled *'In the Garden',* featured in the August 1889 edition of *Studio Notes*. As the wife of Walter Gandy, the editor of the *Notes*, she made regular appearances in its pages almost always in the form of watercolour studies of young children.

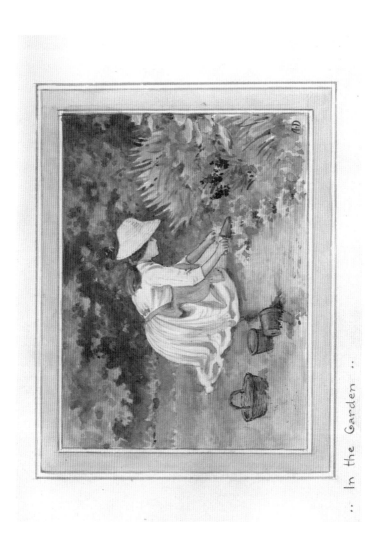

'In the Garden' by Ada Dennis

The Viennese Ladies Orchestra
A.E. Pearce (fl. 1873-1930)

The two sketches of the *Viennaese* (sic) *Ladies Orchestra* (overleaf) are by Arthur Pearce, later noted in connection with *My First Night After Defoliaria* by W.A. Pearce, who was possibly Arthur's brother or close relative. The illustrations appeared in Volume 7 (New Series), September, 1886, in the same issue as the *Summer Holiday* piece by Hannah Barlow (see page 29).

Arthur Pearce had studied architectural design at the Central Government School of Design under John Sparkes before transferring to the distinguished Julien's Studio in Paris. He began his working career in London as an illustrator and drawing master before joining Doulton's, where he remained for almost half a century designing architectural features, exhibition pavilions, tile panels etc.

The fascination of these drawings of the *Ladies Orchestra*, which lacks textural accompaniment other than the titles *Back View of Double Bases* and *A Rest*, lies in the striking visual contrast between the flouncing multi-layered skirts, and the somewhat prim high-necked bodices of the ladies. The pen and ink tonal counterpoint of light and dark demonstrates Pearce's skill in etching technique, in which he regularly engaged.

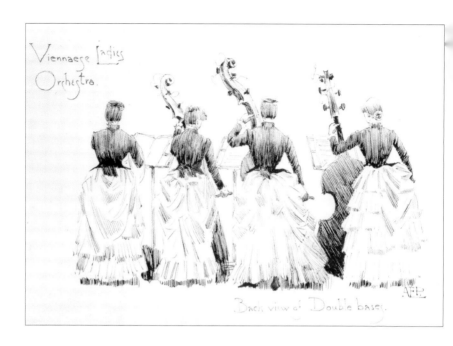

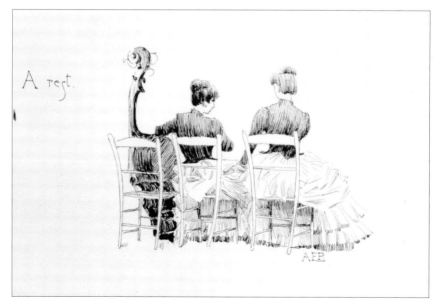

'Ladies Orchestra' and 'A Rest' by Arthur Pearce

Sketches on the Thames
Edgar W. Wilson (fl. 1880-1893)

Five pencil sketches of views on the Thames appeared in the December, 1884 issue of *Studio Notes*. These were by Edgar W. Wilson who specialised in landscapes of England and Scotland, castles, marine subjects etc., which were etched on plates and used on Doulton Ware. Later in his life he embarked on a new career as art critic of the *Pall Mall Gazette*.

The two sketches selected from the group are both views from Lambeth across the Thames to the North Bank, possibly drawn from a window at Doulton's. Each contains as its main focus a notable landmark: the early eighteenth-century St. John, Smith Square by Thomas Archer, and The West Towers of Westminster Abbey by Nicholas Hawksmoor. The St. John's view is at high tide, and the downstream Westminster Abbey view is at low tide. What is perhaps most immediately striking to the modern eye is the richly detailed accretion of industrial and commercial structures tumbling down to the riverbank. Today these have all been replaced by imposing office blocks and towers.

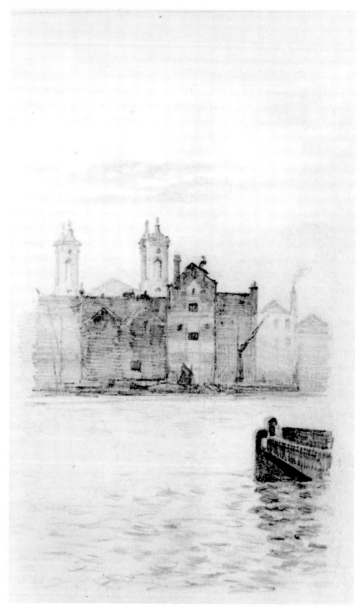

*Sketch from Lambeth across the Thames to the North Bank
by Edgar W. Wilson*

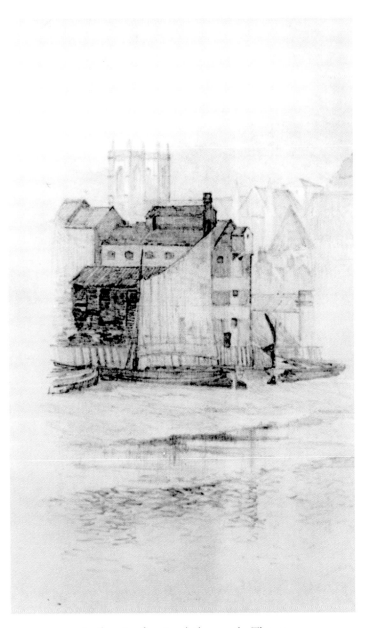

Another view from Lambeth across the Thames

Bird Studies
Florence Barlow (fl. 1873-1909)

Florence Barlow (the younger sister of Hannah Barlow) was a regular and varied contributor to *Studio Notes*. Her faltering efforts at writing a ghost story are noted on page 100. Her professional speciality was in the drawing and painting of birds, in which she excelled. Like her sister, Hannah, she was fascinated by birds and animals and devoted her life to studying them. Over the thirty-six years of her employment at Doulton's she completed tens of thousands of designs on vases, jugs and plaques, nearly all featuring birds. Early in their careers the sisters had agreed to divide the terrestrial and celestial kingdoms between them; Hannah presiding over the former and Florence, the latter. Unlike her sister, Florence made a determined effort to move with the times and later, at the turn of the century, when the market had become tired of the conventional decoration, her style became freer and more stylised, although still recognisably based on bird forms. She was twice successful in showing works at the Royal Academy Summer Exhibition, first in 1884 and then in the following year with a watercolour entitled *Canaries*.

The two pages of drawings included in the present selection appeared in Volume 10 (New Series), June, 1887, together with the work of Ada Dennis already shown (see page 18) and studies by Florence Lewis, Arthur Pearce and others. The four pen and ink studies include a splendidly groomed Prize Yorkshire Coppy (see overleaf) which must have been a treasured rarity. The watercolour studies make a firm statement close to Florence's heart. The gaudy plumage of the Australian Parakeets and Cardinal Bird, is in marked contrast to the pair of rather dowdy blackbirds (see opposite). An onlooker got short shrift when questioning her at the Crystal Palace Bird Show as to why she cared to copy that *'plain-coloured bird when there were so many prettier ones'*. Florence was devoted to every form of bird life from the most exotic to the most mundane, and to her all varieties were equally fascinating.

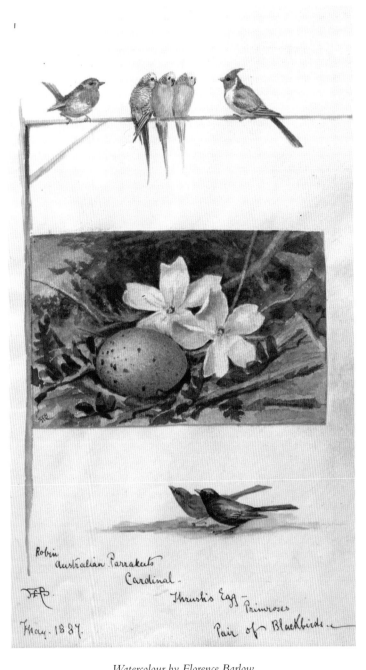

Robin
Australian Parrakeets
Cardinal.
Thrush's Egg –
Primroses
Pair of Blackbirds.

May. 1887.

Watercolour by Florence Barlow

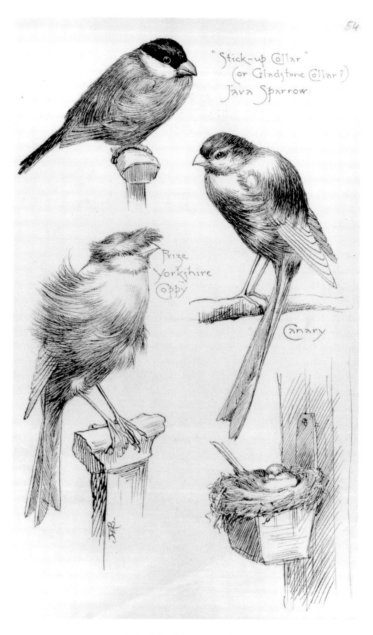

Sketch by Florence Barlow

A Summer Holiday
Hannah Barlow (fl. 1871-1913)

Hannah Barlow was, after Tinworth, the most illustrious of the Doulton artists. We are fortunate in knowing a great deal about her family background and early career. She grew up in idyllic country surroundings and, with her brothers and sisters, developed a passion for the countryside with its teeming animal and bird life. She was the first woman to be employed as a pottery decorator by Henry Doulton, specialising in animal and, for a time, bird subjects. She shared these interests with her sister Florence, who accompanied her on the *Summer Holiday* described.

By the time of the holiday piece, which appeared in Volume 7 (New Series), September, 1886, Hannah and her sisters Florence and Lucy were confirmed spinsters, living in comfortable circumstances in the respectable Clapham Common district of south London. Hannah also had a country cottage at Wraysbury with all manner of animals, almost amounting to a private menagerie. Whether she had acquired this second property by the time of the country holiday is unclear, as the account appears to be retrospective.

Remoteness is not a feature associated with Surrey today, and no doubt the location of the isolated shepherd's cottage where Hannah and Florence stayed, is now transformed into stockbroker-belt suburbia. In Hannah's account the farm animals naturally claim most attention, from the rousing welcome squawked by forty geese, to the unwelcome attention of a brood of little pigs rubbing *'their little fat sides'* against the sketching easels of the two rather sedate ladies. The concern for security and the locking up of the cottage after breakfast each day explodes the modern view that countryside thieving is an exclusively late twentieth-century phenomenon.

A SUMMER HOLIDAY.

After many inquiries and much anxiety for fear we should not meet with a cottage in which to spend our summer holiday, my sister and I decided to take a shepherd's cottage in a quiet part of Surrey, our friends having spoken highly of the farmer's wife under whose care we should be.

All being arranged, we set off one bright afternoon from town, with our sketching materials, and a large hamper of provisions. Some thirty or forty miles of railway travelling had to be done, and then we took a waggonette to finish our journey to do which we had to drive about five miles.

The country grew wilder and

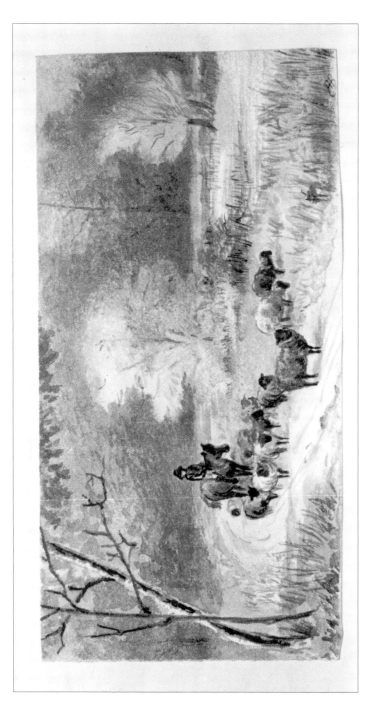

Sketch by Hannah Barlow

wilder, and we began to think our driver had made some mistake, but we said nothing. At last he pointed out a fine old farm house standing on the border of a large common. We felt quite cheerful to think so pretty a place was to be our home for the next few weeks, but no — When we reached the gate we met two women carrying a loaf of bread and some wood. They told us they were on the way to the cottage to light a fire and get us our tea. The cottage we found after some ten minutes more journeying. It stood alone in a field, out of sight of other buildings, and the garden was not enclosed by any fence. It ~~was~~ had a very rustic appearance, but as the evening was drawing in we did not have time to see much of the surroundings.

One of the women stayed to act as our housekeeper. She was but a frail body, and in the night contrived to become very ill, and for some days caused us much anxiety on her account; however, when well again, she was a cheerful little soul.

Early next morning we were roused by a great noise under our window, and on looking out we counted forty geese standing in a group and calling to us! We felt the day had begun well with a welcome from so many friends! After breakfast the housekeeper generally locked up the cottage and went to the farmhouse, while we went sketching, returning to our dinner at five o'clock. One day on our return, we showed the old lady our sketches.

She said we were very clever indeed
but that there was <u>one</u> thing we
could <u>not</u> do and that was, to
make an old gentleman (who lodges
at the farm) speak. He had lived
there several years, and had scarcely
spoken to anyone about the place
all that time. Of course we at
once felt it our duty to prove that
she was wrong.

The next morning we found
much to interest us near the farm-
yard. After a short time, the old
man came out for his usual walk
We took no notice of him but kept
on closely with our work, only being
interrupted now and then by a
brood of little pigs which came
round to have a look at us and
to shake our easels by rubbing
their little fat sides against them
They were like an attack of neuralg

We grew quite to know when they would come.

Things went on thus for a few days, when at last the old artist came forward and spoke. We were soon on quite a friendly footing, and his kindness and help made our holiday doubly pleasant. He told us of good views and walks, and showed us some lovely paintings of the neighbourhood and of views abroad. We quite looked forward to our walk between tea and supper with our old friend. He was very chatty and made the evenings most interesting to us. My readers may think it strange for two girls to have gone to so quiet a spot alone, but I think it is a proof of our sedate manners when the old artist asked if

we remembered such and such
a thing in the Great Exhibition
of 1851. If his astonishment
could have been seen when he
heard that all that had happened
before our day! Even our old
housekeeper was much disap-
pointed on finding we did not
remember the Coronation of
William the Fourth! Half the
pleasure of telling us how good
a view she had of the crowd was
lost — poor old body!

Our wish was to take many
studies home of animals and
landscape. So one day we begged
the farmer to lend us a cart-
horse to sketch. About breakfast
time one morning a man came
to our cottage leading a very
large half-broken colt. We ran
eagerly out and giving us the

rein he said that he wanted
to speak with a man in the
next field and that he would
return almost directly. But we
never saw him again or any-
one to help us until about five
in the afternoon. There we were
—left with a fidgety young horse.
We took it in turns to hold him
while the other sketched, and
so we toiled through the day.
The horse would tread upon the
garden ground, and the earth
being soft he sank nearly up
to his knees, and at one time
it was with great difficulty
that we kept him from tumbling
into the ditch, as he was stretching
his neck to catch sight of some
horses at work in a distant field.
That day was unlike the other days
of our holiday — it was by no

means short.

At last our holiday came to an end and we had to say goodbye to our many friends. The two blind pigs, numerous cows and calves, horses etc, and the rough old sheep-dog which used to invite himself to dinner sometimes. The holiday was too short and for a long time we missed the evening stories told us by our old housekeeper. Of the deaths she had witnessed and the ghosts she had encountered, and her good night when all was told — "I suppose we may as well bar the door, though if thieves want to get in they will, however we try to keep them out". No thieves broke in while we were there, and only one late visitor called, whom

when we had secured a stick and a few other handy things in case of need, we found on opening the door, to be the old red cow which had come into the porch and could not turn round, and until we suggested it, seemed not to have thought of backing out again.

I often look back to this peaceful holiday, when I am sitting alone at my work and it is pleasant to think of the many little kindnesses we met with from the countryfolks.

H.B.Barlow

My First Night After Defoliaria
W. A. Pearce

This entertaining and instructive account of a night spent hunting the Mottled Umber Moth in Epping Forest, appeared in the seventh issue of *Studio Notes*, dated March, 1885. W.A. Pearce is unrecorded in the lists of employees at Doulton's, although Arthur Pearce was a prominent and distinguished architectural designer and talented artist who remained in employment at Doulton's for fifty-seven years. It is tempting to link the two Pearces, as both contributed consecutive articles to the seventh issue. Arthur Pearce, the son of an architect, wrote a substantial piece on the five orders of architecture, immediately followed by the moth-hunting account here reproduced. As the custom was for the volume in preparation to be passed to each contributor in turn so that he could append his piece, it seems likely that the two Pearces shared a home, perhaps as brothers.

The entomologist Pearce and his friend, Jones, were evidently tough, determined and highly spirited young men, not to be deflected from their purpose by adversity. The prospect of walking at least two miles each way late on a December evening, from the nearest railway station to the moth-haunted woodlands of Epping Forest and then, with dangling lanterns, clambering up trees in drenching rain, would today dampen the resolve of all but the most resolute.

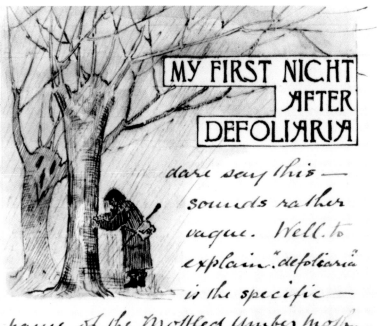

MY FIRST NIGHT AFTER DEFOLIARIA

dare say this — sounds rather vague. Well, to explain "defoliaria" is the specific name of the Mottled Umber moth, known scientifically as Hybernia defoliaria.

Never having taken this insect, I made arrangements with my friend Jones, to visit one of its haunts. So on the sixth of December we took the 7.3 p.m. train from Liverpool Street Station to Wood Street, on the outskirts of Epping Forest. Our kit comprised a satchel (holding some four dozen

small boxes and a lantern) a
thick stick and a macintosh.

The weather was rather squally
when we left the city. but we hoped
it might clear up. when, however,
we left the train at Wood Street Station
a regular gale was blowing, after
debating whether to turn it up or
not, we decided we would have
a look at the ground. Our
destination was "Cook's Folly" a
small wood, about two miles from
the railway station. Before we
got there it commenced to rain
so donning our macs. we made
up our minds for the worst, we
arrived at the wood about 8 o'clock
lit our lamps. and commenced
examining the tree trunks. branches
bushes. etc. working straight
into the wood, Keeping a lookout

for ditches. bogs. and old tree stumps
one of which trips me up, and deposits
me softly on a soil composed of well
decayed leaves and rain water, I —
arise relight my lamp and determine
to keep a better lookout on the ground.
when I hear a shout from Jones of
"Defoliaria" and coming up to him he
pointed out a very fine specimen on
the branch of a birch tree, and was
very conspicuous, the light of the
lantern on its delicate wings, throw-
ing it into strong relief, it was —
what is known as the "barred" variety
and is perhaps the most beautiful.
Jones having boxed it, we proceed.
the next one taken was out of arms
reach, so it is gently disturbed and
watched till it settles again, some-
times we had to climb for them. which
we do with our lanterns in our mouths,

that is, suspended by means of a
wire handle about six inches long
which you hold with your teeth —
proceeding in this way we took
about two dozen, amongst which
were some very good varieties.
Looking at my watch I was surpris-
ed to find it was half past nine
and as we wanted to catch the —
10.20 train, I whistled up Jones.
and we made tracks for the road,
which after a while we found.
packed up our lanterns. etc and
tramped back to the Station. event-
ually reaching Dulwich soon —
after twelve. feeling. damp, cold,
but satisfied.

A few remarks on the life history
of the Mottled Umber moth will —
perhaps be interesting to the reader.
The genus Hybernia belongs to the

group of moths know as geometra.
all the larvæ (or caterpillars) of this
group are called geometers or loopers
from their peculiar manner of crawling
which they do by bringing up the
claspers (or what you might term their
hind legs) close to their prolegs. thus.

then extending the body fix by the
prolegs, and draws up the body again
proceeding, by a series of strides.
with surprising rapidity. When
at rest, they have a great resemblance
to small twigs. etc. fixing by their
claspers and streaching their bodies
out quite stiff. the mimicry being
intensified in some by protuberances
from the body like buds on a stalk
. this must be an immense protection
from the attacks of birds.

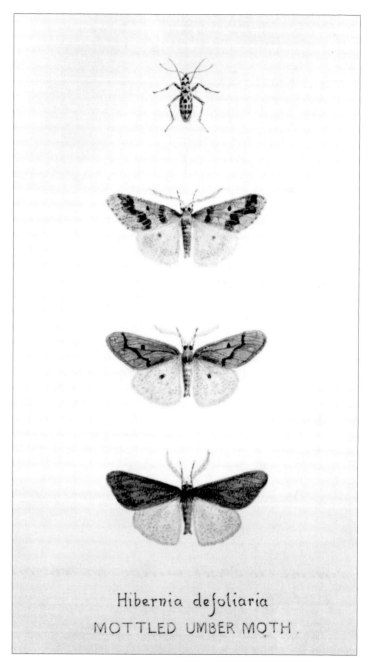

Hibernia defoliaria

MOTTLED UMBER MOTH.

Sketch by W.A. Pearce

The Geometræ consist of **88** genera, comprising 283 species native to Britain, the moths mostly fly after dusk, and when at rest expand their wings flat; with a few exceptions, they may be taken in the daytime by beating bushes trees. etc. so as to make them fly, also at rest on tree trunks. fences. etc, and after dusk when on the wing by means of a net. a lantern also being useful, a practical entomologist always keeps an eye on the Street lamps, which (on favorable nights) attract many good species, which you can secure by scaling the lamp post and boxing the

moth when settled. an eye must also
be kept on stray policemen.

The Genus *Hybernia* is composed of
five species. the females are all wing-
less. The eggs of H. defoliaria are
deposited towards the end of December
the larvae emerging in may. and
feed on the leaves of the oak. elm, birch
and hawthorn, they become full fed
in July. when they change into the
pupa or chrysalis state. The perfect
insect appearing in November and
December, these dates being modified
by the state of the weather.

The variety of color and markings
which occur in this species is wonder-
ful, the sketches herewith represent
three of the more distinct varieties, between
each of these there are intermediate
varieties so gradual, that it is difficult
to determine where the different form

commences. These remarks refer
to the male insect only. the female is
quite a different looking object
(the first figure in the sketch) and
would be passed over by not a few
as a Spider, Beetle or something
else equally distant from its real
character. — W.A.P. 22/2/85.

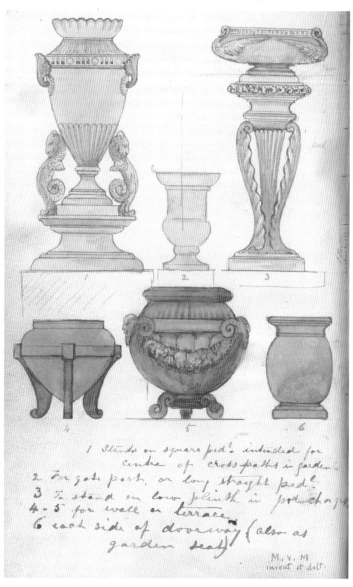

1 Stands on square ped: intended for
centre of cross paths in garden

2 For gate post or long straight ped:

3 To stand on low plinth in portico or gate

4 - 5 for wall or terrace

6 each side of doorway (also as
garden seat)

M. V. M
invent et delt.

Designs for a terracotta garden vase by Mark V. Marshall

In Progress. Completed.
Mark V. Marshall (fl. 1879-1912)

The two watercolours overleaf are by Mark Marshall, one of the most talented of the Doulton artist-designers and modellers. His contributions to *Studio Notes* ranged from satirical and humorous poetry to political and philosophical tracts. The two studies, which appeared in Volume 8 (New Series), December, 1886, show the completion of the great chimney which came to dominate the Lambeth skyline, an event celebrated by proudly sporting the Union Jack on the uppermost rim of the newly built chimney. The surrounding murky, smoke-filled air is a reminder of the pollution caused to the environment by the constant firing of the kilns, fuelled with noxious untreated coal. The relative height and bulk of the new chimney is well conveyed by a shift of scale, which reduces the existing chimney to a relatively insignificant secondary feature. The designs opposite for a terracotta garden vase appeared in Volume 1 (New Series), May 1885.

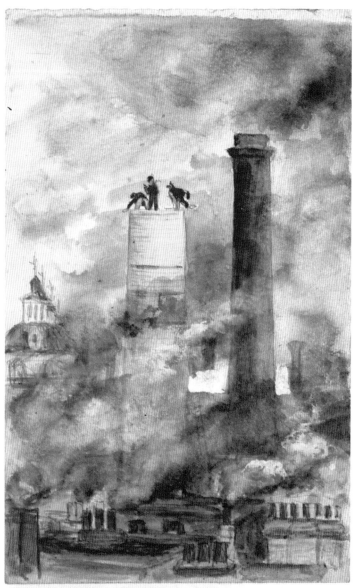

"In Progress".

M.V.M.

Watercolour by Mark V. Marshall

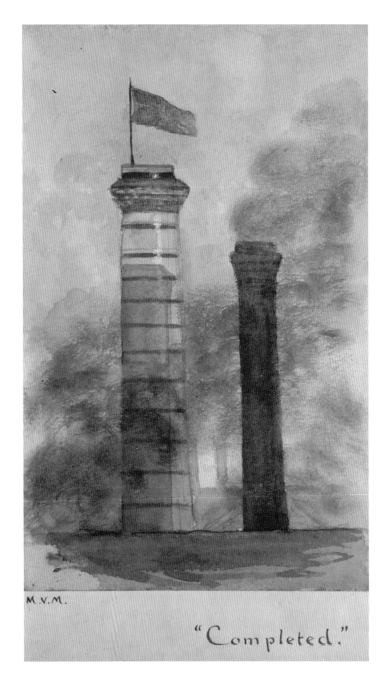

M.V.M.

"Completed."

Watercolour by Mark V. Marshall

53

Letters to the Editor

Those students of social behaviour resorting to newspapers and magazines for their insights into popular views and prejudices will often find the letter columns of these periodicals the most revealing. *Studio Notes* is no exception, and in Volume 8 (New Series), December, 1886, two letters appeared which tell us much about the attitudes and expectations of the employees at Doulton's. The first letter is from the same Arthur Pearce who provided pen and ink drawings of the *Viennese Ladies Orchestra* (see page 22) in the previous issue. He voices a *cri-de-coeur*, which has echoed down the passageways and corridors of industry and commerce for as long as these enterprises took responsibility for offering refreshment to employees. Like so many widespread practices now taken for granted, the origination of the custom is obscure. Henry Doulton introduced many innovations directed at improving the working conditions of his employees; consequently the provision of refreshment rooms formed a natural part of that benevolence. The Aerated Bread Company tearooms under their more familiar initial ABC, which Pearce considered to be so superior to the in-house provision, were a common sight throughout London until relatively recently.

The second letter is signed simply 'Nemo' and has unfortunately eluded attempts to identify its author. It ingeniously teeters on the edge of credibility until gradually the author's demands so overstep the threshold of credibility that the whole piece enters the realm of fantasy. One possible clue to its authorship is offered by the handwriting, which is suspiciously like the neat copperplate of the ubiquitous editor – perhaps however, he merely copied it out from the less legible original.

Dear Mḷ Editor.

 Will you allow me, through the medium of "Studio Notes" to ventilate the subject of the Refreshment department connected with this building.

 It seems a curious thing of such an organization as the Art Department in which we work, containing as it does distinguished

Ladies & Gentleman Artists, that it should boast of a Coffee shop no better than that patronised by the labouring classes. How such a very third rate catering shop could be established and much more how it could possibly continue to exist without protest expressed openly & publicly is an anomaly not to be solved. Protest of a very general character has always been plentiful, but of a private & makeshift kind, so that it has not commanded the attention which a combined Effort would Ensure. Every one, almost, is acquainted with the very Excellent Aerated Bread Companies Depôts, to be met with in all parts of London, the success of these Establishments and the "long felt want" they have supplied so

admirably, is only too apparent to
the Casual observer. Their bill of
fare is as moderate as it is good
and the system upon which the thing
is worked is altogether un exception-
-able. It is so frequently said
that one cannot get a better cup of
Tea, Coffee or chocolate than the
A.B.C. supply you with for 3d &
the bread & Butter, Scones, cakes, Ham.
Eggs &c &c are Equally Excellent
in quality & reasonable in price.
The A.B.C. go on the principal of
plenty of Value & quality for your
money in Every particular; for
instance, Each customer who
orders T. has it made specially
for him in a separate pot so that
he gets the refreshing beverage as
it should be to be Enjoyed.
what a contrast this is to the
black brewed concoction served

out from our Kitchen for T. Most
people now a days know that T.
allowed to brew in the leaves &
stalks until the tannin is extracted
therefrom, is. to say the least, injurious
let alone the nasty harsh bitter flavour
produced. the constipating influence
of it are very much augmented,
and the beverage in this form
frequently brings on other serious
complaints, which ignorant people
attribute to other causes. but the
Philosophy of the Tea pot is now too
well known for me to enter into
a disquisition on it _ the question
to be asked is, who would not
prefer a good. palatable and
reviving cup of the favourite
beverage for 2ᵈ or 3ᵈ a-la. A·B·C·,
to the bitter & injurious penny worth
served out in this Establishment
 In the question of Coffee &

Cocoa we cannot have a better precedent than that supplied by the Company already referred to and it is needless here to go into the most improved and accepted way of making them. It only remains now for a majority of those who avail themselves of the Luncheon & Tea rooms here, to respectfully submit their wants at head quarters and there is no doubt but that the question would be attended to and put upon a more rational basis.

It may be argued on the other side that the establishment in question barely pays it way, (at least so I am told) and that consequently the firm would not feel disposed to advance money on the starting of a new system, but the probable reason why it has not

succeeded under the present role
is that there are a great number who
do not patronise it and that also
such small prices of Articles, (although
they are indifferent) is not conducive
to remuneration. but I take it the
firm would be perfectly satisfied
if the concern merely paid its
Expences with a little balance to
the good. We do not want to be
under any extra obligation to our
Employers or to ask any thing
unreasonable of them, our plea is
that the food from the Catering
department should be Eatable &
drinkable and in accordance
with our Everyday habit.

I trust it will not be
inferred that a slight or want of
Confidence is placed upon those
who so amiably and admirably
attend to our wants, much

praise and thanks are due to them for so ably working the kitchen and other rooms – they only attend to and work upon the lines laid down for their guidance and they would carry out, I feel sure, this new system as admirably as the old one.

It is proposed that a vote be taken on the subject as a test of this reform in the Refreshment department at some future date and it is to be hoped that an effort will be made in favour of it.

Trusting I have not trespassed too much on your indulgence or taken up too much of the valuable space in your journal, I have the honor to be, Sir,

Your Obedient Servant,
Arthur E. Easey.

Dear Mr Editor.

Will you allow me to make known the wants of most of the male employées of the Art Department, through the medium of your journal. We feel very much the want of a smoking room on the premises, a room where we can enjoy our pipe for a few minutes and read our papers. Now that the winter is coming on, one does not care to turn out in the rain, sleet or snow for lunch, and therefore we are deprived of the fragrant weed, as there is no place in the building where smoking is allowed. The ladies have a play-room with a piano, swings, and no end of other pleasures, besides which they enjoy the ever-changing views from by far the best room in the building. It seems a pity that

such a room as this is not made
more real use of, for artists of both
sexes to study and enjoy every phase
of varying nature. Most likely the
ladies do make sketches and notes
from the windows — let us hope so.
But what becomes of us poor fellows?
We have a dining room certainly
— a few feet square, which is a
consideration in inclement weather.
But what we need even more than
this is a room for a quiet pipe, a
game of chess, cards, dominoes, whist
or a quiet read.

We are by far the most
important of the sexes in the
Department, though not so numerous
and yet we have no conveniences
or comforts that would make the
leisure hour more enjoyable. All
artist chaps smoke, and we in this
department would be less than

human, and certainly not artists
if we did not do the same.

While I am writing to you,
I might, in view of next summer,
ask if it is not possible for us to
work on very hot days in our
shirtsleeves and slippers. One
must have artistic surroundings
and habits as an incentive to
work.

And would there be any
objection to our going out now
and then for a quiet stroll to
observe character &c at the river-
side or in Lambeth Walk, to note
the harmonious colours of the
barges and fruit & fish stalls, and
in fact to seek inspiration and
pick up useful ideas generally?

And is there any insuperable
obstacle in the way of establishing
a liquor bar on the premises.

Believe me, a glass of foaming draught stout is the finest thing out these cold mornings, and you cannot, until you try it, conceive the heavenly ecstasy that fills you when, on an oppressively hot summer day, you imbibe leisurely the glass of lemon squash, just touched up with a dash of sperrits.

 Yours &c.

 Nemo.

In the Garden
Ada Dennis (fl. 1881-1894)

Ada Dennis was married to Walter Gandy, the editor of *Studio Notes* and, in addition to a prolific output as an artist-decorator in her own right, decorated pots designed by her husband. Starting as an assistant in the stoneware department, she then moved to Faience, Carrara and Marqueterie Wares. Her typical work took the form of charming idylls of childhood, with Kate Greenaway-like figures happily engrossed in innocent pleasures and pastimes. She was also, as her watercolour sketches in *Studio Notes* demonstrate, a highly-skilled watercolourist. This sketch (another from the same volume is reproduced on page 18), forms part of a series by artists such as Florence Lewis and Florence Barlow, and others (including her husband), which occupy over twenty pages of the volume for June 1887.

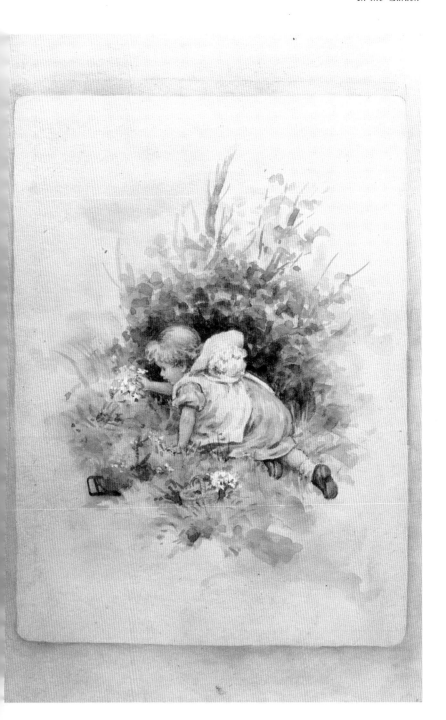

The Design Competition: A Wall Decoration

From as early as the third issue of *Studio Notes,* Walter Gandy had introduced the idea of competition. This worthy enterprise, like several other editorial initiatives, appeared to have a somewhat chequered history. Only a minority of the surviving volumes contains a competition item, and it must be supposed that the somewhat demanding nature of the subjects, the ranking of the entries, and the prospect of public criticism, must have discouraged many. By 1887, in Issue 12 (New Series), Gandy was becoming somewhat desperate. A notice is appended to the contents page stating:

'A prize of 5/- had been offered for the best artistic contribution in this number, but as only 3 sketches were sent in by the date named, the Editor thinks it best to withhold the prize for another occasion.'

The subject for the competition in Issue 6 for December, 1884 was a design for *'A Wall Decoration'* to be carried out in *'any or all our wares'.* The criterion for judgements was to be *'freshness of treatment'* and, in order to ensure independence, John Sparkes agreed to be the judge. Sparkes was by this time, devoting most of his formidable energies to running the South Kensington School of Design, and was much in demand for his views of design education. He had however, retained close links with the Lambeth School and the Doulton Art Pottery, which he had himself conceived and helped to found.

Sparkes' ranking of the ten submitted designs and accompanying comments were relayed to the readers of the *Notes* by the Editor who, by virtue of having submitted no less than three entries himself, was not perhaps the most dispassionate of reporters. The most detailed (and complimentary) comments refer to Gandy's own submissions, including the statement that, despite one of his entries being awarded only an equal fifth ranking (with others), *'Mr. S. would however like to have it in his own hall'.*

Not surprisingly, the next competition subject which was changed from *'A Puzzle Jug or other Quaint Vessel'* to *'A Fireplace and Mantelpiece in all or any of our Wares',* attracted only six entries, including one by Gandy, whose highly professional and elegant design was awarded second place by the judge, Wilton P. Rix.

The Design Competition

10 Designs were sent in on Nov^r
27th. M^r Sparkes kindly judged
them and placed them in this order
of merit:—

1st W. Gaudy.
2. J. Stamp
3. A.E. Pearce
4. J. Stamp.
5. { W. Gaudy
 W. Rowe
 7. Pope
 W. Gaudy
6. { E. Bishop
 A.G. Budden.

Two subjects were given but as all
tried for the first, it is only necessary
to repeat that one. "A Wall decoration,
"complete for a Hall 13 ft high. In any
"or all of our wares —.—.— the chief
"essential being freshness of treatment."

".To be drawn to 1/2 inch Scale".

As near as can be remembered. These are some of M^r Sparkes' remarks:—

No 1. Quiet. If for a hall with plenty of light the brown bands above and below frieze are too dark; if for a dark hall, the body of wall is not heavy enough.

2. Sensible and thoroughly practical.

3. Nicely touched in but far too busy and elaborate for its purpose.

4. Unfinished but with a good idea.

5. Disqualified from taking a higher place
(W.g) because of absence of any pattern in the tiling. M^r S. would however like to have it in his own hall.

5. Too wriggly.
(Poke)

————————

not (See Over)
The next Subject will ∧ be :—
The best **Puzzle Jug** or other **Quaint Vessel** for holding Liquids. Models or

71

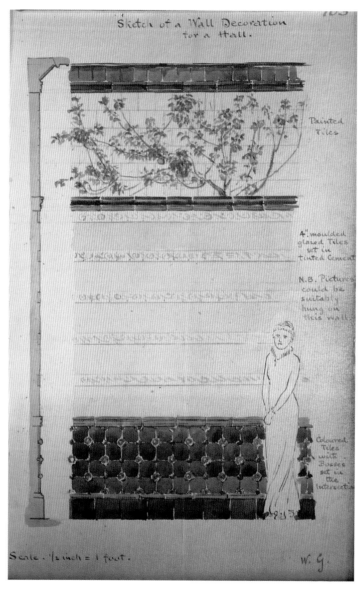

Design by Walter Gandy (editor of Studio Notes) awarded 1st Place

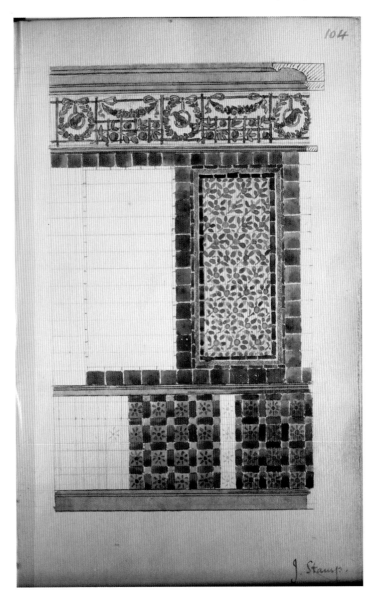

Design by J. Stamp, awarded 2nd Place

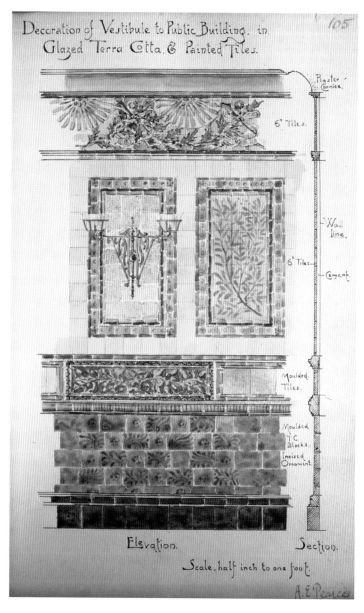

Design by A.E. Pearce, awarded 3rd Place

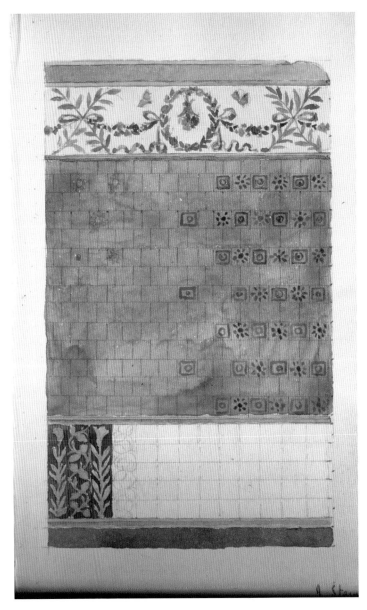

Design by J. Stamp, awarded 4th Place

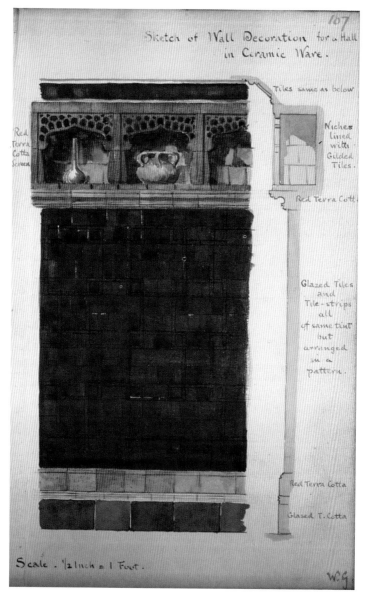

Design by Walter Gandy, awarded joint 5th Place

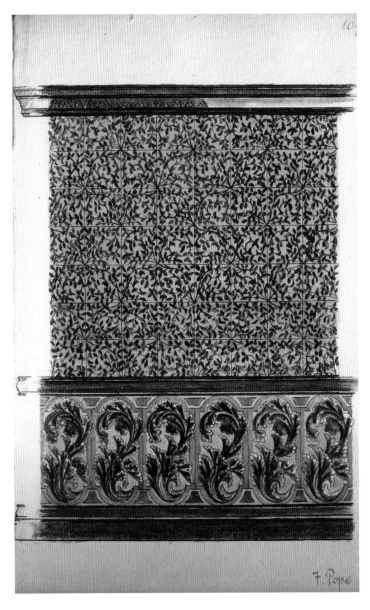

Design by F.Pope, awarded joint 5th Place

Lambeth Laments
Mark V. Marshall (fl. 1879-1912)

Mark V. Marshall, one of the most talented artists to devote his career to Doulton, was a regular and varied contributor to *Studio Notes*. In the first issue, distributed in December, 1883, he attempted an ambitious though muddled analysis of the nature of beauty entitled *The Thing of Beauty*:

'Let us erect a grand tomb, or, richer, a mausoleum, of stone Oh!
– Eureka! – of Doulton Ware. Ah! Joy!!! Here is the thing of beauty that will endure for ever.'

Lambeth Laments appeared in the third volume, forming an ironic pendant to the Wilton P. Rix piece. In it, Marshall bemoans the increasing elaboration and fussiness which he, rightly, felt detracted from the vigorous directness of the earlier pieces. Later in his career, he was occasionally guilty of applying ornament over-extravagantly. In general however, throughout his thirty or more years working for Doulton, Marshall's own decoration retained all the vitality and fresh originality of the early work he so admired.

Oh! Doulton ware, sweet Doulton ware,
How varied all thy charms once were,
With youthful vigor bold and free,
How simply chaste you used to be.
 Young Doulton ware!

Like greek athlete stout Doulton ware,
With "Gres-de-Flandre" for thy sire,
Thy manhood's prime felt Tinworth's fire,
It seemed thy strength would never tire.
 Oh! Doulton ware.

Dear Doulton ware, Oh have a care.
Thou art grown up in luxury
And Roman splendours garnish thee
Thy bounteous wealth drags heavily
 Proud Doulton ware.

Oh! harken now, dear soul beware.
A warning shout comes from afar,
You "over decorated" are,
And are not now what once you were.
~~~~~~~~~~~ Oh! Doulton ware.

Now creeps around the chilly scare.
Does youthful vigor glide away?
Oh! thou art fading! thing of clay,
Thy manhood tending to decay.
~~~~~~~~~~~ dear Doulton ware.

Away! bad dream, oh! cease to care
For Italy's voluptous craze,
Look back at Barlow's modest ways,
The love and zeal of early days,
~~~~~~~~~~~ Of Doulton ware.

And be thyself, be Lambeth still,
And Phœnix-like, by fire refined,
Begin again with earnest mind
To truth and beauty most inclined
~~~~~~~~~~~ dear Doulton ware

Reminiscences of the Past
The Origin and Infancy of Lambeth Art Pottery
W.P. Rix (fl. 1868-1897)

Wilton P. Rix was the first art director at Lambeth. Appointed in 1870 he played a key role in the development of the pigments, glazes and slips, and clay, all of which were crucial to the success of the salt-glaze and faience wares. This account of the origin and infancy of the Lambeth Art Pottery (illustrated by Walter Gandy), which appeared in the third volume of *Studio Notes* (circulated in April, 1884) gives an unparalleled insight into the struggles and disappointments, as well as the great achievements, of the early years.

From W.P. Rix's account it is clear that the public reception of the salt-glaze pieces of pottery exhibited at the 1871 International Exhibition at South Kensington, was the turning point in the fortunes of the Art Pottery. The contrast between the primitive roughness and elementary colouring of the Doulton pieces which, despite their utilitarian appearance, were presented as ornamental wares, and the highly refined and sophisticated factory porcelains of Messrs. Minton, Wedgwood and Worcester exhibited nearby, startled the public. Then, as now, the appeal was in the immediacy and vitality of the pieces. The incised mark of the scribing tool called a style, formed patterns on the soft-surfaced, newly-raised pot, indicating that this was the work of an individual artist-craftsman. These pots were the first in a long line of unique pieces, the continuation of what is now called Studio pottery.

Rix's recollection of events some ten or more years earlier is perhaps not always reliable. It is unclear whether the work of Hannah Barlow was included in the 1871 Exhibition, although Edmund Gosse, Tinworth's first biographer, mentions it: perhaps her employment was initially irregular. Among many nuggets of esoteric information otherwise unrecorded, is the inverted V mark, made by the brothers Edwin and Walter Martin, who briefly assisted both Tinworth and Arthur Barlow in applying the coloured slip on to the incised decoration, before joining their brother Robert to form the Martin Brothers Pottery.

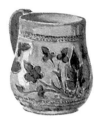

Etched by Arthur Barlow and coloured
by Edwin or Walter Martin, 1872

The Old
Doorway.

Lambeth
Art Pottery.

Reminiscences of the Past.

The origin and infancy of Lambeth Art Pottery.

Few of those associated together in the commencement of the Lambeth Art Pottery conceived that it would so rapidly extend to its present dimensions; and few except those who have watched its development through the earlier stages are able to appreciate how largely the success of present achievements is based on the failures and disappointments of the pioneers in the work, who steadfastly persevered often in the teeth of crushing difficulty.

It is thought that a short account
of the "dark ages" may have some
interest for those ~~who now enjoy~~
~~the benefit~~ of later days.

The year 1866 saw the first dawn
of desire to improve the work of
Lambeth Pottery. Previously the
attempts at ornamental treatment
were confined to a few Terra Cotta
vases and one or two moulded
filters. During this year Mr Tinworth
was introduced by Mr Sparkes, and
at that time he might have been
seen stowed away in a smoky
corner of the long and dusty room
in which his old studio now stands.
With no other furniture than a
square board on an old tub for
a table, and a chimney pot for a
seat, he commenced modelling
some medallions and bosses for
Terra Cotta, the potters around

looking considerably askance at the innovation. At this time no person in the employ of the firm had any accurate knowledge of archi-tectural drawing nor could anyone correctly read or understand a scale drawing and the first order for architectural Terra Cotta was so far an enigma that the drawings could only be carried into execution by the help of friendly explanations from those outside. During the close of 1866 the first attempts were made to produce Art Stoneware. A few good forms of Vases and Jugs were thrown on the wheel in Fire White Clay and lathed. No decor-ation was attempted except a gadaroon and bead runner, with bands of blue and brown colour or the top dipped in Blue. About thirty of these pieces formed the

leading features in the exhibit at
the Paris Exhibition 1867.

Very little apparent advance was
made during the next two years
but the encouragement of Mr Sparkes
and the late Mr Gregory caused
Mr Doulton to determine in 1870 to
attempt an advance of Salt glazed
stone ware to the position of an Art
ware. A series of decorated jugs
and vases were prepared for the
International Exhibition 1871 at
South Kensington. In some of
these pieces the first attempt was made
to fill Blue colour in lines etched
upon the work, but the etching was
done with a style when the work was
nearly or quite white hard. Several
of these were etched by Mr Tinworth,
who also produced in the spring of
1871 his first pieces etched in the soft
state, after his now well known

method. No dots or boxes were however used till much later.

The effort of several months, with some failures, resulted in the production of about 60 pieces which were sent to the International Exhibition of 1871 at South Kensington. Amidst a mass of confusion the writer proceeded to unpack and set out what were then considered to be the "pride of Lambeth". With a sinking heart the labour and interest of many days were relegated to a dark and shadowy recess under a window ledge where not one soul in a hundred would ever dream of approaching. Yet how could we dare to ask of the august committee any higher position? Were they not surrounded on all sides by the choicest and daintiest of china and of porcelain, luxurious and tasteful in decoration?

To be even classified in the same
division – was not this sufficient
honour for pots that had ever before
been known as neighbours only to
the plebeian blacking bottle or
the uninteresting drain pipe. Nought
but shamefacedness could ever come
of emerging into the light of day
under such surroundings; yet such
was to be. The last was in this case
to be first. Passing along the
dreary and straw bestrewn corridor
just as the display was complete
Mr. Soden Smith enquired by
whose authority these goods were
so badly placed. A subordinate
was forthwith ordered without
delay to clear a large glass case
and much to the chagrin of
other exhibitors, elegant specimens
of ceramic work were unceremoniously
cast aside to find another lodgment.

while the "new stone ware" found itself
promoted at one stroke to honour
and repute. From that moment its
future was secure. It had been acknow-
ledged as an art-ware and passed
from the region of coarse utilities.
On one side it was flanked by
Wedgwood's choicest specimens and
on the other by the tastiest of china
from Mintons, while opposite stood
the triumphs of Worcester. It need
not be said that amidst such
incongruous surroundings the
strange new ware could not fail
to attract notice from its very con-
trast. Immediately upon the open-
ing of the Exhibition connoisseurs
made it their purpose to criticise
and better still, to patronise and
purchase. Representatives of foreign
museums at once secured a share,
and the Queen directed certain to be

reserved for her own collection, so that in a few days only one half dozen of the least striking pieces remained unsold.

While such marked success was more than unexpected it is only due to the discrimination of Mr. Henry Doulton to say that from the outset he deliberately set himself to accomplish this result and on the first day of the publication of the Exhibition programme a year before announced that intention to his subordinates.

Very shortly after the opening of the Exhibition Miss Hannah Barlow and her brother the late Mr Arthur Barlow were introduced to the work, and to them with Mr Tinworth belong the origination of the present method. Very various tools and means were first experimented on

and a number of different clays
were also tested. Of colours there
were none except the blue now
called the "painting blue" and
the brown now called "fine
ochre". The former through want
of knowledge nearly always turned
black in firing and the latter
seemed little else than mud.
. Disappointments and dismay soon
followed and very discouraging
must have been the early months
of these pioneers in the work. They
had no studio in which to work.
For many months an odd corner of
the old showroom (now occupied by
rooms 35 to 38) was all they had to
call their own and customers
coming to purchase one or two of
the few specimens yet produced per-
sistently intruded on the privacy
of the very public studio by craning

their necks over the folding screen which indicated the only boundary to the "sanctum" of the Lambeth Art Pottery. The intrusions of buyers, of critics and of unwelcome breezes were however by no means the only disturbing elements. At present no command had been obtained over the material and kiln after kiln gave nought but irritation and despair as the productions of a week were brought forth "stunted" to be presented to the artist only in the form of shapeless fragments which mocked their persevering efforts. Twelve months of uphill labour seemed to have produced little result and it is certain that at the Exhibition of 1872 the expectations of 1871 were not by any means fulfilled. Other stone potters exhibited and certainly in colour and

material surpassed Lambeth
Pottery. But this was only the in-
centive to new endeavours and in
the autumn of 1872 very marked
progress was made. At this time
the younger brothers of Mr Wallace
Martin were assisting Mr Tinworth
in the colouring and in trying
experiments; but about the end of
this year they retired and eventually
joined their brother in establishing
the pottery with which they are still
connected.

Mr Butler also joined Mr A. Barlow
soon after and for some time
occupied with him the room now
marked No 41. In February 1873
the introduction of girls for colouring
the ware marked an important
crisis and a serious innovation in
the annals and traditions of
Lambeth Pottery. Miss Youatt

and Miss Fisher were soon joined by
Miss Emily Goodman and were for
a short time supervised by the late
Miss E. J. Edwards, who had just
commenced designing on the ware
and these occupied a part of a
large room now indicated by
rooms No. 48 and 49.

At this juncture the introduction
of the Lambeth Faience was
contemplated and removal being
necessary, the "painting girls" were
placed in No 42 under the super-
vision of Miss S. Goodman, who
for more than 7 years had charge
of this branch.

The amount of ware produced
was very limited as will be seen
when it is stated that all was
sorted, priced and kept in the
small room now No 43. Probably
only 30 to 36 pieces a week were

turned out, and of these only a
limited number were successful.
From this point the progress
was so rapid that it seems to be
impossible to guage it. By bounds
and leaps it reached a point
which put all doubt of its future
capabilities at an end, and
many of the pieces prepared for
the Vienna exhibition of 1873 were
equal in force and vigour of design
and in richness of colour to some
of the best of our later efforts. The
Lambeth Pottery exhibits for 1876
at Philadelphia made the most
pronounced sensation both here
and in America. The showroom
(now rooms Nos. 35 & 38) was arranged
with the Doulton Ware and
Faience and the result of an
invitation to view brought 1500
visitors in three days, and the

press at times was so great that on the day M^r Gladstone came it had been thought needful to shore up the ceiling of the office below lest the weight of people above should break through.

It is needless to pursue the history of the work beyond these earlier days except to say that with the intro-duction of pâte sur pâte for the Exhibition of Paris 1878 another great stride was made and the amazingly varied collection prepared on that occasion secured the highest obtainable honour of the "Grand Prix" and placed "Doulton Ware on an acknowledged equality with the productions of Minton, Wedgwood & Worcester in public estimation.

It is certain that great advances have been made even since these

days but the object of this sketch has been to remind those who at present enjoy the benefits of past exertions that much of the pleasure and interest which now surrounds the accomplishment of the daily effort, is due to the indomitable perseverance of those who—strangers in an unknown land—set themselves in the face of obstacles at times almost overwhelming to raise the crude stoneware of Lambeth to the proud distinction it has now attained.

W.P.Rix

Description of the Sketches.

No 1. 1867. In fine white clay. Bands
6½" high coloured blue & ochre.

No 2. 1871. In fine white clay, top dipt in
8½" high ochre. Ornament etched by
W Byron Sen' & blue rubbed in.

No 3. Late in 1872. In "No 1" Clay. Etched while
10" high soft by **GT**. Coloured by Martin Λ

No 4. 1872. Etched by **ABB** (Mr Barlow). Coloured
5" high by Martin Λ.

No 5. Early in 1873. Etched by **ABB** and numbered
5¾" high **8**

 Coloured by Miss Youatt **Y1**.

No 6. Early in 1873. Etched by Miss Edwards
6" high **E**. Stamped background col.º blown.

No 7. Early in 1873 or late in 72. In Claret
5½" high Clay with stamped flowers in same.

No 8. Same time as last. A trial of Light Blue
6¼" high Clay. Etched by Miss HB Barlow.
 Blue rubbed in lines.

No 9. 1873. A trial of C Clay Slip by G.T.
9½" high Coloured by **Tg1** (Miss Goodman).

No 10. 1873 (One of the earliest with date as
7" high shown here DOULTON 1873 LAMBETH
 Etched by Mr Butler **FAB**.
 Background of tiny flowers figured in
 C. Clay. Coloured by **Tg1**.

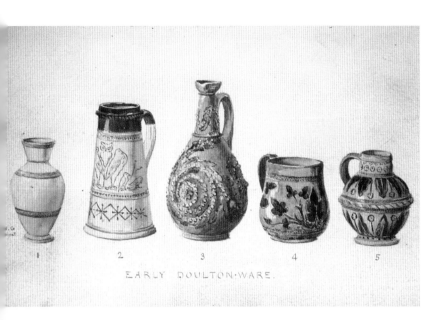

EARLY DOULTON-WARE.

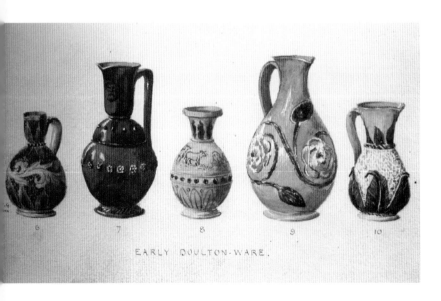

EARLY DOULTON-WARE.

Watercolour sketches by Walter Gandy of the pots which are
individually described and listed on pages 97 and 98

Competitions: Designs for a Show Card

In the December, 1886 issue of *Studio Notes* the editor introduced two separate competitions evidently a favourite method of attracting contributions from his colleagues. The first took the form of a literary contest. A faience artist, Miss E. Ruddock, contributed an ambitious piece on the German poet Schiller, which the judge viewed with mixed feelings:

> *'the expression…is graceful and generally correct but several of the sentences are not well constructed, and the punctuation is frequently wrong.'*

Florence Barlow, the younger sister of Hannah, offered *The Haunted House and What Happened In It*, a ghost story in five chapters. The judgement on this entry was particularly cruel:

> *'…the story of the Haunted House has evidently been written in a great hurry and the author has consequently overlooked many errors of grammar, punctuation and expression. The descriptions are diffuse, and the dramatic element has not been made at all effective.'*

The third entry, *Epitaphiana* by Mr. J. Gibson is roundly condemned:

> *'There is less excuse for this writer in the matter of punctuation. The Epitaph, as written by him, is incomprehensible.'*

It is not surprising that, with this very forthright public criticism, Walter Gandy, after editing fifteen volumes of the *Notes*, was beginning to despair of persuading colleagues to make contributions. He writes in his introduction to the competitions:

> *'It takes a great deal to discourage the editor as regards Studio Notes, but he is getting a little disheartened.'*

The second competition section was on more traditional lines. The subject set was *Designs for a Show Card*, which attracted an unusually high standard of response, including one from Mark Marshall and another, characteristically of a very high technical standard, from the editor. The six entries submitted have been included in this section.

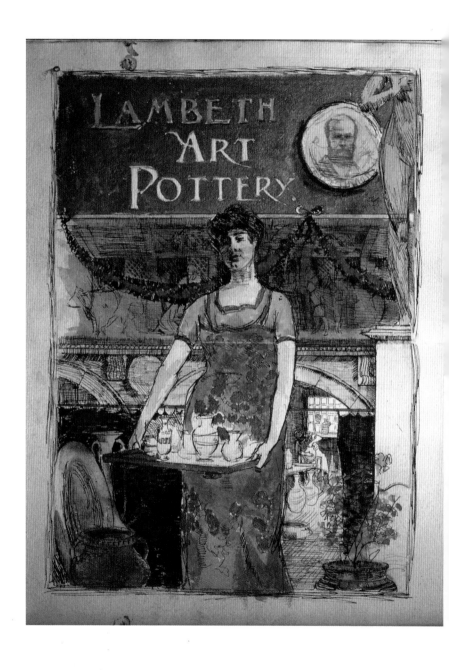

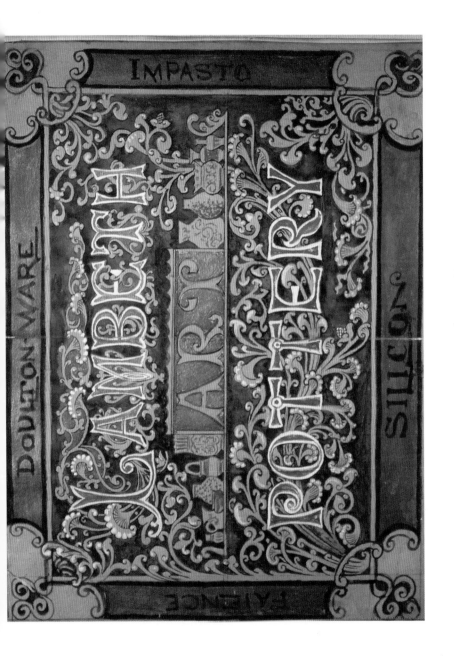

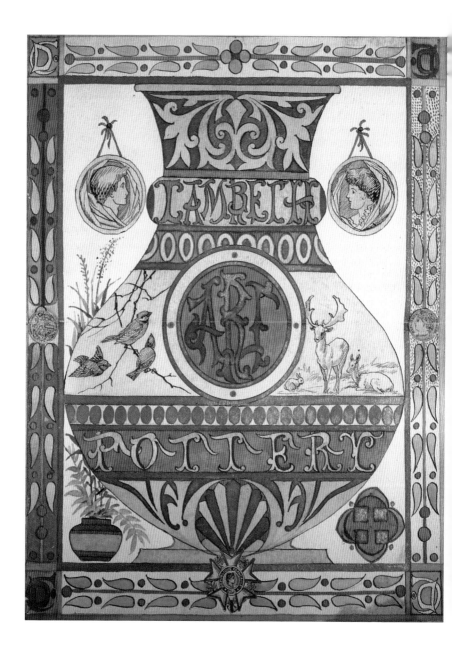

Report of the March Show
Anon (Walter Gandy, fl. 1880-1932)

The schoolmastery tone of this piece is typical of the editor Walter Gandy and it must be assumed, that although unsigned, the reader would have been in no doubt about its authorship. Gandy's sharpness in criticising contributors for their perceived shortcomings was extended freely to comments on their professional work. Examples of these criticisms have already been quoted in the Introduction. However, the *Report of the March Show of 1884* which appeared in the third volume of *Studio Notes*, is rather more diplomatic and wide-ranging in its scope.

Gandy's comments provide an invaluable insight into the working and costing methods of the studios. *'Stagnation of trade'* had adversely affected sales, particularly of the more highly priced items. The costs of each piece was separately calculated, taking into account the time expended on the decorative treatment of the background etc. *'Inordinately slow'* work carried out by assistants was one cause of excessive cost; another was the over-use of costly gilding. These factors had to be assessed by the Head of Studio, who apportioned and supervised the work, as well as creating the unique design for each piece. It can readily be imagined how such an unstandardised procedure was beset with administrative and other problems.

Various styles in current production are commented upon and, although some terms are self-explanatory, others are unfamiliar. The Repousseé Ware, a newly introduced technique, later called Natural Foliage Ware, depended on the use of real leaves which were pressed into the soft clay and then (according to Eyles) carefully removed, leaving a faithful impression. However, it seems more likely that the leaves were left in position to be carbonised in the firing, thus contributing a distinctive pigmentation to the final piece. Impasto Ware was a form of relief modelling using pigmented clay slip, which closely resembled the French Barbatine technique.

Report of the March Show.

Generally.

The present exhibition of ware is highly satisfactory in every branch. The variety of treatments is very extended. More individual thought and attention is evinced than usual and more intelligence shown in appreciating the capabilities and values of the various materials dealt with. The firing during the last four months in all parts has been more successful, thus producing a much larger proportion of perfect results and more quality and brilliance in the tone and colour of the ware. The designing is more accurate and very much released from overloading. Indeed, the grounds for this objection have almost disappeared.

The present excessive stagnation of trade has caused the sales to be very

small, but this is not to be attributed to any want in the merits of the ware produced.

The analysis of the cost of production which has been taking place during the last few months has however revealed several points which need very serious attention, vz:-

1. ~~Some~~ designers, frequently, and many occasionally, attempt treatments and produce designs utterly inadequate to their cost. The effects produced are in no way more pleasing, artistic or meritorious than many others obtained more easily and therefore more cheaply. It is most desirable that a designer should consider not only if the method or the treatment is new but whether it is also the most direct for obtaining the effect required. Purchasers entirely disregard the question of method -

effect is chiefly sought after.

2. It is clear that several assistants especially those working on pattern backgrounds are inordinately slow: some pieces ought to have been completed in two-thirds the time actually occupied.

These matters cause serious loss, as the pieces have to be sold at a reduction or kept in stock on account of their very high price.

Heads of rooms are urged to greater attention on this point.

Doulton Ware.

The wares introduced at the last show have been greatly improved. "Champlevée" though not attracting many sales is very good in treatment and the designs well adapted to the method.

"Repoussée" looks better for being on larger vases; the introduction

of figures is a good feature.
"Crystalline" Silicon is much better.
The addition of Red Brown slip
in the designs has removed the
previous coldness, though this is
liable to blister if badly fired.
The scale of the work is better and
also the distribution.

The "inlay" work in outline under-
glaze is a method deserving of
further attention and if other
slips than claret are tried, will
give the varying depths of colour
required. Outline figure work
could be well accomplished in
this way.

The sketches of fish in slip under-
glaze are not so good as at first.

Best figured designs are steadily
improving both in Doulton Ware
and Silicon.

Some of the thumbed work is also

very carefully done and it is hoped
that further practice will make
it possible to produce still finer
work.

Silicon designed work not being
largely represented in this show,
cannot be reported on. The inlaid
polished Silicon ought however
to make good result at next show.
This ware needs the utmost care.

Faence.

Marked progress is being
made in the work. Greater
vigour of treatment is apparent
and greater variety also. More
individual thought is manifest
and there is less impression of
all the works having emanated
from the same studio.

The specimens of work executed
on coloured bodies are very prom-
ising, and the combinations of

barbotine colours and glazes in some pieces are especially happy, shewing good opening for future work.

The introduction of coloured enamels in some pieces as a background also suggests another hopeful line of work, though at present it needs more experience to bring it to perfection both in colour and effect.

The attempt to introduce gold on the faience work demands the very careful attention of the designer if it is be at all successful. At present, the gold has been used with too little consideration of the result. Good designs are overwhelmed by a profusion of gold diaper in the background, which, though adding greatly to the cost, is more than thrown

away in the result. Gold should be used with the utmost caution and perhaps a good rule for work would be to use it for *emphasis* rather than for ornament. Thus bands, beads and outlines are safer than diapers or casual treatment of details in gold.

Impasto is decidedly improved and both designs and colouring are very satisfactory. The modelling and drawing of most of the work is better. The conventional design requires to be more judicious in its scale and character. There is room for improvement in the finish of these articles, which are left ragged and uneven at the bottom edge where the slip has not been smoothed away evenly.

A very important arrangement deserving of notice here consists in

the introduction of Impasto work for figures, designed on flat slabs or tiles, the joints being arranged to follow the outline as in stained glass. This method is capable of most promising development and should be steadily pursued.

An Electric Light Bracket at the new house of Mr W.S. Gilbert.

From British Architect.

Mch 14. 84

Report on the Show: October 29th 1884
Anon (Walter Gandy fl. 1880-1932)

As in the previous report on the March Show, Walter Gandy's schoolmasterish tone is discernible. This time however, the strictures are even more severe! *'Want of balance...wrong construction, bad perspective, crooked work, careless ground laying, bad finish ..'* are castigated in a crescendo of criticism.

Separated by a few pages of correspondence, the short piece *The Home Department*, which Gandy acknowledges as his own work, is somewhat more diplomatic and optimistic in tone. Clearly, the economic malaise had intensified and there is reference to five-day working, presumably a reduction from six. However, there is comfort offered in referring to Minton's *'two and a half days'*. Workers had been dismissed but they were either slow or else incompetent. The most striking aspect of the handling of the economic crisis was the request from *'Headquarters for all to re-attend the School of Art'*, which Gandy regarded as *'without doubt just and right'*.

Walter Gandy emerges more clearly as a spokesman for management, and the *Studio Notes* partly as a vehicle for direct instruction from Henry Doulton. Another aspect of the economising strategy, which collectors of Doulton Ware will find instructive, is the encouragement of the relatively cheap Series Ware, which repeated the same design on identically-shaped pots many times and which sold well.

Report.
on The Show Oct 29ᵈ 1884.

The interval between this and the last show being nearly six months, such progress as has been made is more perceptible.

It is to the credit of those concerned that notwithstanding the discouraging influences of the last half-year, such steady work has been produced.

It is difficult to point out any one branch in which there are not to be found excellent specimens of the ware

Here and there, however, carelessness is still to be observed in minor points, which less pardonable than in the earlier times of more limited experience, and less ambitious pretentions.

Among these may be named :—

want of balance in parts of design
wrong construction, bad perspective
<u>crooked</u> work, careless ground laying
bad finish of slip &c.

In Doulton Ware, some large
vases with modelling in low relief.
and some umbrella stands, with
modelling by roll decoration are
specially praiseworthy.

The demand for Doulton Ware
has considerably slackened, and the
brighter key of color now adopted.
in glass. and other pottery decoration
does not allow the dark coloring of.
Doulton Ware to hold its own. Colors
must therefore be kept brighter and
the general tone lighter throughout.

For this purpose whiter bodies
will be used. such as C Clay & Fine
Clay, and a new set of lighter colors
(half the depth) for backgrounds have
been introduced.

The Gilt Silicon is very good, and if some little attention were paid to improving the even laying of the Slips would in time commend itself largely

Great care should be bestowed on finish in this ware. 1st because being unglazed the slightest scratch or defect is readily seen. 2nd Because the introduction of Gold presupposes a point of excellence which is at once outraged by perceptible blemishes in other parts.

The Gold decoration on Faience and Doulton Ware, not being successful will be discontinued.

In Faience and Impasto, the large work especially is bold and well executed, and it is encouraging to know that both these classes of ware have been freely purchased. Good and effective flower painting

is still sought after more than
conventional decoration and red
shaded backgrounds are at present
most acceptable.

In tile designs, the new enamel
decoration on dry or smeared back-
ground is a pleasing change and
would be very saleable if not so
expensive.

Silicon Olive Brown requires
more careful study as to color
of Best figuring work. It is too
dull. More Silicon White and W
Clay should be used on it.

Silicon Slate should not be
so heavily decorated with Purple
Brown. Silicon Red Brown and
W. Clay will give better value.

Thumbing work is steadily
improving and with care may
yet become an important item
of the work.

The continual demand for a much larger proportion of cheap repeated work has made the changes indicated in the last report absolutely necessary. The Firm however hope most sincerely that with the revival of trade generally, a more steady demand may spring up for unique work, but it is evident that for some time to come, the very serious expense of maintaining this department can only be met by rigid economy in the work itself and a somewhat discouraging retrenchment of the more advanced and expensive productions.

In view of this it is desirable that attendance at the School of Art and other opportunities of study should if possible be continued, as without this there is little hope of holding the distinctions already obtained.

Referring to the cheap repeated

wares, these have met with a ready sale and orders continue to come in freely. Heads of rooms should endeavour to keep greater uniformity It is very difficult to pair up such work, and if not accurately alike. All pieces should be worked to to the first pattern and not copied from each other

The decorated stoneware has good promise of development and should have careful attention

The new Stencil work is also likely to be very successful and is capable of varied treatment

The adoption of the new Fine Clay renders all these methods more certain and gives a much greater range of color.

The Home Department

That things are looking brighter is evident in many ways. The last Show was a very good one (the best for a long time), and the Report of the Show is quite cheerful in tone. It is true that several have left, but if we look we shall find that they were either too slow or else incompetent. It is true that the 5 days work still continues, but that is better than only 2½ days, stated to be now the rule at Mintons. It is true that great quantities of cheap ware are now required to be produced — only the more reason to make both them & the higher class wares still better than they have been.

The request from Headquarters for all to reattend the School of Art is without doubt just and right, but I

think some allowance should be made
for those students who prefer to attend
equally good classes elsewhere than at
Lambeth. There are more masters of
designing than one, and some are better
~~and~~ qualified than others to retain the
confidence of their pupils.

————————

I hope Mr Rix will pardon me
for making free with the following
business communication addressed to
him by Mr A B Johnson, manager of
Barretts Patents.

30 Oct 1884.

Dear Mr Rix
 Before you fix
A day for Bacchus to the fire.
 To see him stand
 Perfect and grand
Is but a natural desire.
— Whilst yet his flesh
 Is soft and fresh.

m

The Troubles of a Sketcher /The Man of Many Clubs
Percy Ke p (fl. 1881-1890)

Percy Kemp's contribution to the Lambeth Art Pottery Studios took the form of providing outline designs, which were finished and coloured by the artists and their assistants. He later made more direct use of his talent for sketching by leaving Doulton's and becoming a journalist. The account of his first sketching expedition up (and down) the Thames, accompanied by highly effective and amusing cartoon-like illustrations, demonstrates how ill-prepared and ill-informed was the ordinary man over such matters as tides, and even the difference between up- and down-stream. Bizarre encounters, such as the meeting with the *'wary Orangeman'*, add to the vivid impression of innocents abroad.

The Troubles of a Sketcher appeared in the first issue of *Studio Notes*, setting the pattern for regular contributions from Percy Kemp. The third issue contained a series of sketches, also included in this selection, as well as a further series of sketches, Thomas Smithers' *Grand Climax. The Man of Many Clubs* (see page 135) demonstrates Kemp's mastery of the incisive strip-cartoon genre, and helps to explain his later defection from Doulton's to a more direct application of his talents in the press.

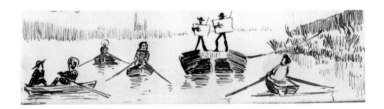

The Troubles of a Sketcher

One fine Saturday I made the acquaintance of a gentleman who had had some experience in sketching from nature. My soul was fired by his poetic descriptions of sketching tours. We hastily concocted a plan for spending our afternoon with brush and palette. Not giving any time to a meal, we started at 1.0 from Vauxhall by rail to Putney. On arrival there and asking the way to the river we came upon the picturesque wooden bridge. It was our intention to follow the towing path going up stream, but not knowing which was up and which was down we crossed the bridge and turned to the right, getting out on the mud deposited by the tide. This was disgustingly dirty work, for in some places the mud was in a liquid state. Turning up our trousers we marched

along for about quarter of a mile: then,
finding nothing of interest to sketch we
endeavoured to climb the slimy embankment.
Having done so with difficulty we enquired
of some person how much farther it was
to the Suspension Bridge and were informed
we were going in the wrong direction, so
we had to retrace our steps. This was
retracing in the full sense of the word
for were footsteps left an impression
in the soft mud. Our boots were pleasant
studies, being decorated in monochrome
of mud to the ancles.

Arriving at the bridge we would
not venture on the riverside again, so
proceeded along the small road which
runs parallel to the river. It looked
quite countryfied considering its nearness
to Putney. Having escaped the mud
we were now assailed by the dust
which a high wind was causing to
rise in clouds. After another mile of

this pleasant walking, hampered with sketching materials, we arrived at a plantation of vegetables. We accosted an old woman in the field and were told we were trespassing, but she kindly let us cross by the path which led to a stone wall and palings. Clambering over we found ourselves on the river bank as well and went some distance before seeing anything to sketch. In the distance we spied an old barge stranded by the tide. Hastening to it we found it overlooked a rather well composed view with a barge in foreground and looking down stream. It was now about 3.0 o'clock.

As this was my first sketching expedition I had encumbered myself with an imperial drawing board, three sheets of paper, a large size box of water colours, two dozen brushes, and no water. However, the latter was easily obtained.

So seating ourselves on the forepart of the barge we commenced operations — the wind in our face. After half an hour's hard work trying to keep warm and to prevent the paper being blown away, having knocked the water over and lost several articles, we took a turn up and down to circulate our chilled blood. My friend was quite resolved he would not return without a sketch, so we allowed the rising tide to gradually cut us off from the river-bank (time 4.30). By five o'clock all hopes were abandoned of getting off until the tide was down again.

Having brought no food, and being exposed to the eastwind, we felt exceedingly miserable. We could not retire to the hold, as that was waterlogged.

We hailed a passing boatman respecting the tide, with the answer "it would turn at seven" — Then we should have to wait 2 hours before we could

descend. A most magnificent sunset
presented itself behind the Soapworks,
but how could we contemplate it with
pleasure? Eating was uppermost in our
minds at that moment.

At 8.0 o'clock our vessel floated,
when suddenly we were inspired with
the idea of hauling ourselves in by the
hawser and so getting ashore. With
magnificent energy we did this. To
climb the fence was a hard matter —
it had been newly tarred and spiked.
On the other side were the cabbage fields.
It was dark and we stumbled along
uprooting numberless cabbages and now
and then falling. Quarter of a mile of
this style of progression brought us to a
fence about ten feet high also spiked.
Tossing our things over we were surprised
to hear a man's voice who apparently
took us for a couple of thieves. We
informed him how we came there and

he consented to our scaling the fence. We were in the road feeling as hungry as bears. The first man we saw was an orange-vender who had an unpleasant habit of putting your money in his mouth and forgetting all about it. Having asked again for payment we persuaded him to feel in his mouth, which he did and expressed his surprise at his forgetfulness.

Two miles of walking in the dark put some life in us. We crossed the bridge and reached the town. Entering the first coffee-house we thawed into the semblance of human beings. It was here we made a most tragic and solemn resolve never to visit Putney again. (But I have been there since, under different and more pleasant circumstances).

Percy Kemp.

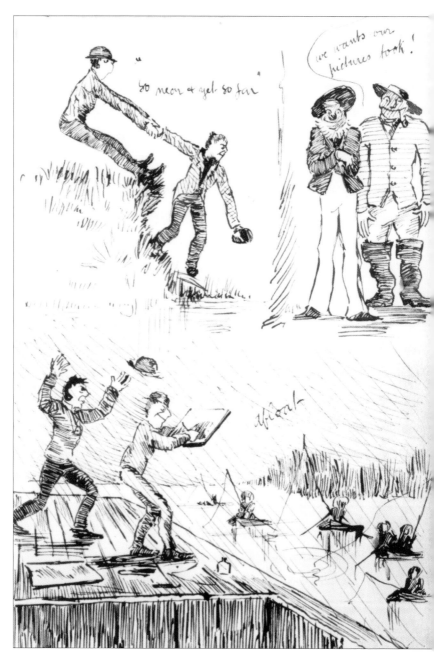

Sketches and watercolours by Percy Kemp

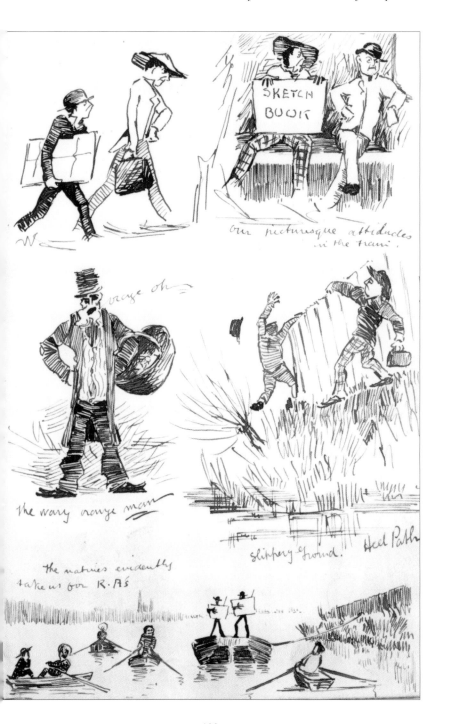

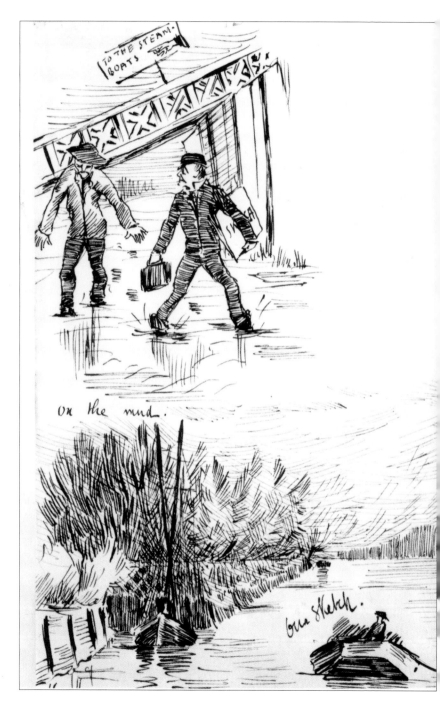

On the mud.

Our Sketch.

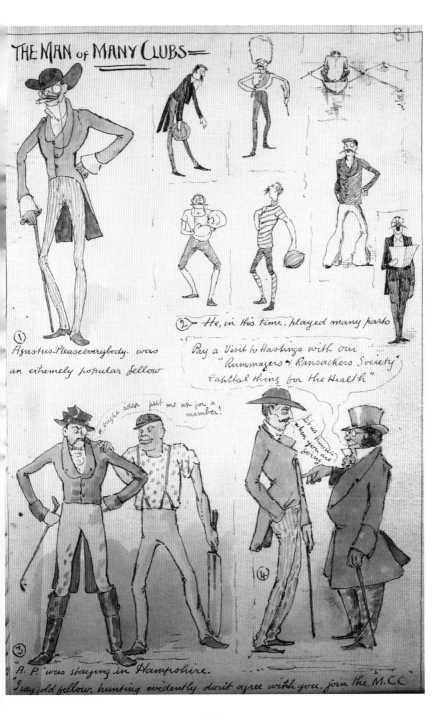

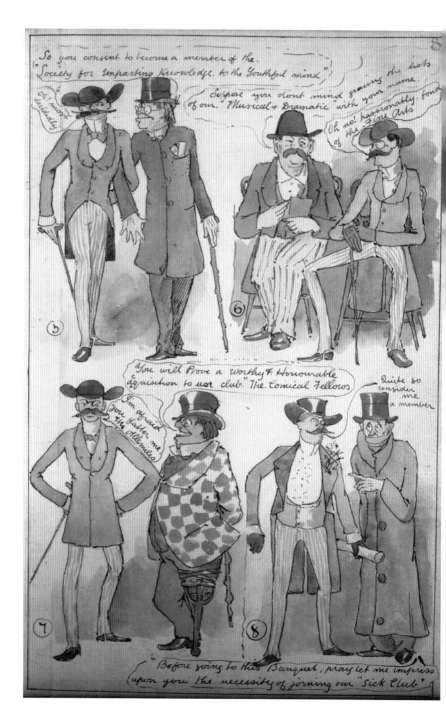

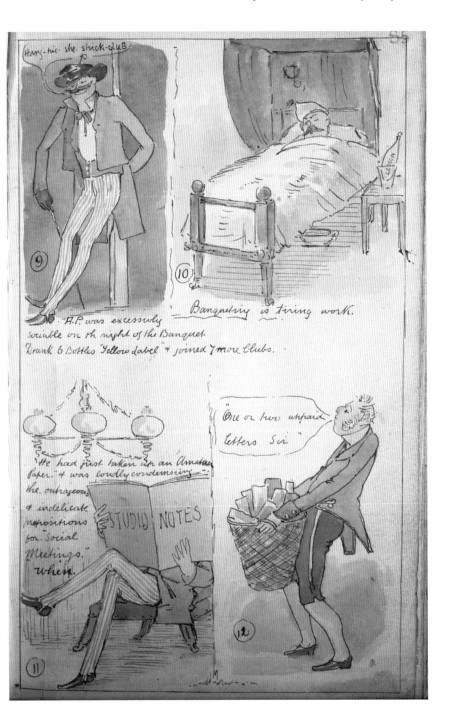

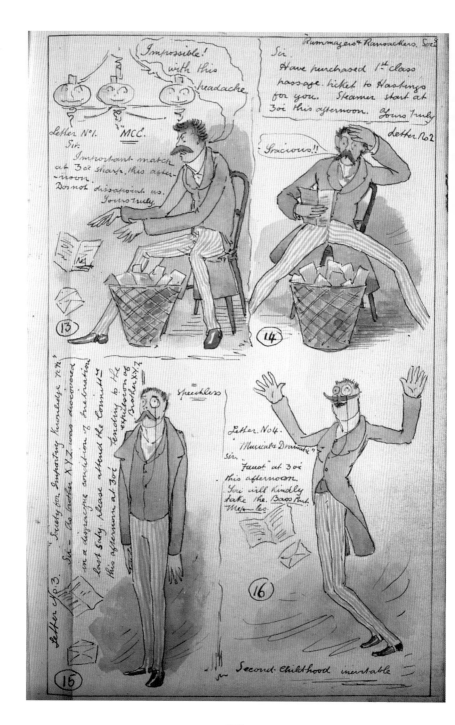

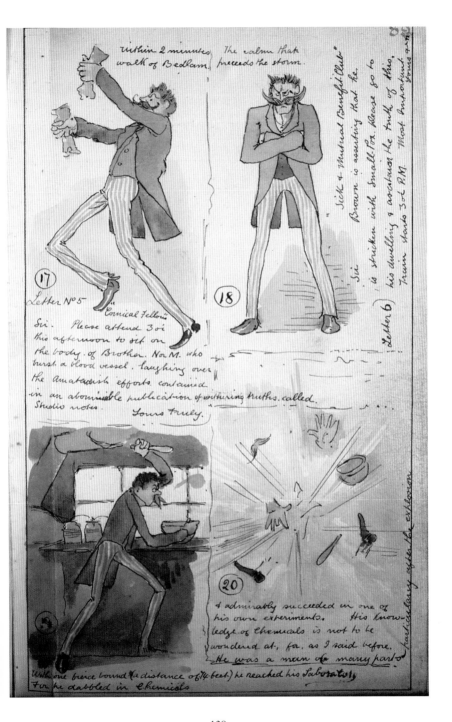

within 2 minutes walk of Bedlam.

The calm that preceeds the storm.

(17)

(18)

"Sick & Mutual Benefit Club" Brown is asserting that he Sir, is stricken with small-Pox. Please go to Letter 6 his dwelling & ascertain the truth of this. Train starts 3 o'c P.M. Most Important yours arm

Letter N°5

"Comical Fellow"

Sir. Please attend 3 o'c this afternoon to sit on the body of Brother No. M. who burst a blood vessel, laughing over the Amateurish efforts contained in an abominable publication of withering truths, called Studio notes. Yours truly.

(20)

& admirably succeeded in one of his own experiments. His knowledge of Chemicals is not to be wondered at, for, as I said before, He was a man of many parts

particularly after the explosion.

With one fierce bound (a distance of 14 feet) he reached his Laboratory for he dabbled in Chemicals

The Home Department
Walter Gandy (fl. 1880-1932)

A regular feature of *Studio Notes* was *The Home Department,* an editorial compilation of news and views relevant to the Doulton employees. *The Report* in the issue of March, 1885, provided the reader with a richly varied *omnium gatherum,* ranging from press comments published in Europe and America, to a spoof concert programme. Today these items provide a fascinating insight into the perceptions and attitudes of the Doulton employees and their contemporaries.

The article in the *Frankfurter Zeitung* (which, but for this piece, might have been entirely overlooked by posterity), is particularly revealing of how spectacular and socially remarkable the newly constructed Doulton buildings in Lambeth must have looked amidst their tumbledown even squalid setting. But for these work-a-day surroundings *'they would have been mistaken for palaces'* according to the German writer Herr C.C. Schardt. All is not praise however, and a splendidly destructive tirade from *Le Figaro* attacks the *'utterly and hopelessly ugly drinking fountains of London',* particularly a recently installed Doulton Ware one in Kensington High Street, although, as Gandy is at pains to point out, the design was not by Doulton.

The penultimate item. a spoof concert programme, directs its aim at several familiar Aunt Sallys: Hannah Barlow's propensity for harbouring pet animals, apparently both alive and dead, is gently mocked; George Tinworth is not only ribbed for his fondness for mice but also, perhaps rather insensitively, for his eccentric spelling. Like most insider house-jokes, the majority of the references are lost on us today, and we can only guess at what lay behind them. At the same time we can only admire the extraordinary sense of community to which this mild, affectionate humour testifies.

The Home Department.

A German newspaper — the "Frankfurter Zeitung" of Nov 26. last — has a long article by Herr C.C. Eckardt, entitled "a visit to 'Doulton's Pottery'". The article is highly appreciative and eulogistic, the author going even to the extent of attributing, in great part, to Mr Henry Doulton's example and endeavours, the improvement in English exterior decoration that has taken place within the last ten years. By the kindness of Mr Pix, I am able to copy a few paragraphs from this article. The excellent translation has been made by a clever young lady now engaged here.

—————

Speaking of the buildings, this German critic says "These edifices have such a stately and yet, at the same time, such an elegant appearance that

if they had not been built right in the midst of shabby working men's houses, and had not had a courtyard adjoining them, containing enormous heaps of pipes and pottery work of every description, they would have been mistaken for palaces. What a contrast these buildings present to the manufactories which surround them! The majority of English factories or mills have such a monotonous, shabby and unartistic appearance. No traces of tasteful decoration are to be seen; these buildings are only intended to serve as a means of producing money, and therefore any ornamentation whatever would be superfluous, in fact, only money thrown away".

Mr Schardt of course compares Doulton Ware to the old Rhenish ware, pointing out that the difference in colour is due to our

firing with pit-coal instead of charcoal. Describing the different kinds of ware (so many & so various as to completely bewilder & overcome the visitor) he says "Of all the kinds of ornament, the charming groups of animals designed by Miss Hannah Barlow, pleased me most. She does not require many lines in order to give her animals character — just a few strokes suffice. Her designs remind me in this respect of the charming Japanese drawings." Mr Tinworth is mentioned at length. "His works are perhaps a little too conventional. ... The weakness of his art is more apparent in his reliefs". (Here I think most people will differ with the critic) "One feels that Mr Tinworth has attempted too much with his plastic clay.. In the choice of his subjects he is also found fault with by many."

Speaking of Faience, Mr Schardt points out its suitability for decorative use of all kinds. He is particularly pleased to find it adopted for "Calorifiers" or Closed Stoves. "Every child in Germany knows something about ornamented Dutch tiled-Stoves, and one often finds really quite picturesque stove-decoration in Dutch farm-houses, or even in rough fisher-huts. When William III of Orange, ascended the English throne, this art was also introduced into England, but it is owing to the aesthetic movement of the recent years, that this ingenious and tasteful decoration of stoves has been revived."

"None of the wares, however, which come under the heading of Faience, are capable of as much artistic treatment, as that known as "Impasto"---- It gives the artist a splendid opportunity for

developing his talent. Examples of
this kind of ware belong indisputably
to the most beautiful of the articles
exhibited.

———————

After briefly mentioning the
sanitary ware, Mr Schardt concludes
by writing "It is not to be denied
that such a spirit of business man-
agement and artistic enthusiasm
has seldom been so happily combined,
or obtained such brilliant results as
is the case in Lambeth. The stoneware
which is manufactured by Doulton
is a national production, which has
won no less renown for the manu-
facturer, than for the artists who
together aim at perfection and have
secured its admittance into all other
countries".

———————

Another critic (in the American

"Art Amateur" says, speaking of Doulton ware generally "It is to be noticed that the tendency of the Doulton decoration of late has been to increased brilliancy and richness of color effects – due largely to the intelligence and untiring energy of Mr Wilton Rix, the art director, who is constantly making new discoveries for stoneware decoration." This magazine gives fair reproductions of two groups of ware drawn by Mr Pearce, and of two of Mr. Eyres' last year's panels "Palissy" and "Della Robbia", rather coolly appropriating the latter in giving full directions to their readers for coloring them in various materials.

Here is another criticism (from the Figaro of Jan 24th). "Of all the utterly and hopelessly ugly drinking fountains in London, commend to me the lately erected specimen in front of the Vestry Hall in Kensington High Street. That there should

be a designer in England who could design such a hideous thing, and a West-End parish in London that permits its most important thoroughfare to serve as a site for it, are facts which would well-nigh tempt Mr Ruskin to recommence his closed series of "Fors Clavigera", and devote a special number to the above depressing incident". This is rather severe, but I venture to think, quite wrong. Though the design was not made by us, I certainly thought it good, and that our working out of it could have resulted in such an eyesore to the above critic, I cannot at all understand. The paragraph looks suspicious enough to suggest the idea that it was written by an interested party.

It is no secret now that Mr H. L. Doulton will shortly enter the bonds of matrimony. Some kind of testimonial is almost sure to be commenced among

us, for Mr Louis Doulton has always been extremely courteous and kind to anyone in our department, and he deserves our very best wishes and congratulations on such a happy event. A representative committee will probably be formed to decide the most appropriate offering to make.

The Conductor of our little Musical Club received a valentine on the 14th, in the shape of a pretty baton. He now thus publicly returns his thanks, and without the poet's permission exposes to the "full blaze of garish day" this awful doggerel :—

"Oh music-loving brother mine,
Accept this humble valentine,
To beat in time those wretched knaves
Who really cannot mind their staves.
To use this baton, you must bat'on
Heads of those who oft are flat on

Violins; likewise that fellow
Who will not tune his grumbling 'cello.
Again just mind that frisky brute
Who "tootles" on the wooden flute,
And when enough you think you've borne it,
Just tap that "time-forsaking" cornet.
'But "O my love like red, red nose"
'Twill be most useful at the close,
When voices all are used in chorus,
(Which makes all good folks just deplore us)
Then hold this rod in sight, above,
Forget not 'tis the rod of love."

General Gordon's sister having seen
and purchased one of the Gordon Jugs,
it was noticed and approved by Her
Majesty the Queen, who seemed so greatly
pleased that Miss Gordon presented it
to Her Majesty for her acceptance. Though
the hero is now dead, I hope it will not
be found necessary to make commercial
capital out of such a sad event, and

restrict the sale of the jugs to any one political party by altering the words on the jug.

The Doulton Ware Columns and Lamp Pedestals at the Showroom door are allowed to get dirty. This is not a good advertisement. "But I thought that Doulton ware and Terra Cotta were cleansed by every shower of rain!" Yes, that is true of pure rain, but here, in London, the rain is never pure. There are about 99½ parts of soot, grit, mud, filth, grime, smuts, blacks, dirt to each ½ of pure rain.

The Dean of Westminster, D^r Bradley has offered to conduct a party of thirty of the Doulton artists over the Abbey on Saturday afternoon May 23^rd next.(This year — not next). Of this number 6 will be chosen from the male department. The selection will have to be made in some

amicable way, perhaps by ballot, or
by good conduct marks, or by reason of
longest service. At all events, the gentlemen
will themselves have to decide the six,
so that they must, for the honour of the
sex, choose the most highly cultured, most
genteel, most intellectual, most charming,
and altogether most representative six
to worthily represent our highly cultured,
genteel, intellectual and charming male
designers. Remember that the remaining
24 of the party will be _ladies_.

Our modellers will no doubt be
glad to see in the Reference Library
shortly, a valuable work (produced with
all the luxury of Parisian type and
illustrations) on Clodion and the brothers
Adam, well known French sculptors
of the last century. Clodion was very
famous for his terra-cottas, and several of
them are illustrated in the book.

The Concerts in aid of the Convalescent Fund have all, I believe, been a success musically. The first was held on 27th January, and the music &c was supplied by the lady assistants, some of whom showed decided talent. Arriving as I did rather late, the polite gentleman at the door offered me a seat which gave me this sort of view of the proceedings. The singers were quite invisible to me. Quite a novelty were two recitations

The only one I had the pleasure to hear was the one by Miss Ada Lilley which I thought extremely good, her enunciation being remarkably clear, and her expression not at all strained or forced.

The 2nd Concert was on Feb 10th. Mr Alec. Charge played some nice violin music, Miss Watt & Mr J. Watt, and Miss Troup played and sang, and with the assistance of Mr Howard Barnard, some members of our Musical Club sang two part songs, in one of which they were also helped by Misses Ball & Davis

The 3rd Concert was on Feb 24th. As I was not present until the close, I can say little about it. Madame Poole and the Misses Cutler sang, Mr H. J. Miles played the violin, and Miss Buckland presided at the pianoforte. Mr Francis Ford gave a Dickens' reading.

Alternately with the Concerts of this series, other concerts are being held for

the factory men & their ladies. The first held on Feb 4th was noteworthy from the fact that the programme was carried out by members of the Doulton family. Mr H. Doulton recited, Mr H. L. & Mr James Doulton sang, Miss Alice Doulton played the harp, and other interesting things were done.

Who were the individuals who obtained admission to the concert of Feb 24th by showing two of last year's tickets with the date neatly altered?

Here are some suggestions for the next Concert, which is, I understand, to be given by those engaged here.

Part. 1.

Variety Entertainment. including solos on the Piccolo, Flute, Violin, Viola, Violoncello, Cornet & Tenor Horn, with occasional vocal items

Mr M. V. Marshall

Guitar Solo. Tuning Up.
 Mr Harry Barnard.
Song "The Captain with his eyeglasses" (Bishop)
 Mr Tabor.
Violin Solo. Variations on
 "Away with Melancholy".
 Mr J. Bread.
Cornet Solo. "Courage brother, do not stumble" (Macleod)
 Mr G. Bearne.
Music hall Song. "I've got something better
 to do, thankyou!"
 Mr A. Orchin.
Bagpipes Solo. "Ye twice ten hundred deities" (Purcell)
 Mr A. E. Pearce
Selection Popular Airs
 Band of Pocket Combs
 Ladies in No 53.

During the interval, Miss Barlow will
introduce her performing dog and her
Wonderful Dead Cat, Mr Tinworth will
exhibit his clever mice, and a daring

trapeze act will be executed by four young ladies. M^r Mott will be in attendance to call or fetch vehicles. M^r Bagshaw will be in readiness with basons.

Part 2.

Chorus. "Oh no, we never speak to them" (Specially Arranged) Double Choir,

 Ladies in No 21; Ladies in No 27

Song "Shivery, shakery, oh! oh! oh!"
 M^r W. Gandy

Cornet Solo. Air from "Time and Truth" (Handel)
 M^r Tabor

Recitation (in character) "Hydrochlorocephalous-
-phlyggllauriferymilrotumwxyz $H^2 \frac{e}{m} \frac{e}{3} + 5x$"
 M^r H Budden.

Song "The Spelling Bee" (Grossmith)
 M^r Tinworth.

Comic Sketch. "Oh! those Amateurs!" (Original)
 M^r J. Eyre.

Concerted Piece "The Cats Quadrilles (Lully)
 All the Violins.

I think special thanks are due to Mr Pearce for his contribution to this number. When I suggested the subject to him, I had no idea that it would entail so much labour as has evidently been expended on such beautiful drawings.

—————— – ——————

Jottings

Mr Colin Minton Campbell, head of the firm of Mintons, died on 8th Feb. He was the grandson of the founder of the works at Stoke which were commenced in 1788.

—————— – ——————

The suspension bridge at Rouen, sketched on the first page of the first number of "Studio Notes", is (or is to be) pulled down to make way for a stone bridge.

—————— – ——————

The Editor's Notebook
Walter Gandy (fl. 1880-1932)

The editor of *Studio Notes*, Walter Gandy, should be accorded the last words in this *'miscellany of amateur contributions'* which he goaded out of his colleagues with a mixture of pleading and highhanded zeal for over six years, amounting to twenty-five separate issues. Eventually, in October 1889, he handed the task to one of the most enthusiastic contributors, Joseph H. Mott (fl. 1880-1950), who succeeded Wilton P. Rix as Art Director at Lambeth in 1897.

The Editor's Notebook was a regular feature of the *Notes* although the title sometimes varied. A variant, *The Home Department,* for the issue March, 1885, has been included in this selection (see page 140). These editorial features provided a vehicle for carrying various oddments of gossip and curious by-ways of information, dominated by the editor's various hobbyhorses. The *Note Book* for September, 1886, is typically quirky in including an arch reference to *'tail-less mice',* revealing that, at this time, quantities of Tinworth mouse groups were being produced. Evidently the tail was individually modelled although the mouse body itself was moulded.

The main item, about plagiarism of images copied from publications in the reference library, was clearly seen as a serious misdemeanour, which could damage the reputation of the firm worldwide. The much prized uniqueness of each piece of Doulton Ware made it *'expensive...and purchased by people of means – people who are sure to see the art magazines and who would be quick to recognise any appropriation therefrom'*. The serious warning is followed by a light-hearted sketch envisaging a disastrous confrontation with a wealthy customer visiting the showroom, whose suspicions are aroused by recognising a copy of a Jules Breton on a vase offered for sale.

In the issue for June, 1887, Gandy included a sketch of a *'Corner of No. 92 Room sketched some years ago'*, which demonstrates his skill as a draughtsman, as well as revealing an otherwise unrecorded stage in the building of the new Lambeth Headquarters. The very last word is provided by the *Rules* which, with typical Gandy regimentation, governed the distribution of *Studio Notes*.

The Editor's Note Book.

∴

Wanted a powerful mousetrap to catch the numerous mice that have lately been seen in the pottery — mice of exceptional anatomy — mice without any tails — tails that were forgotten — mice without tails and yet actually "touched up" and coloured and put in the kiln and drawn from the kiln and nobody noticed that the unfortunate things had not been provided with tails!

∴

No harm will be done by divulging that when a certain willing little gentlemen who had kindly offered to carry the heavy burden, appeared at Mr Rix's door, laden with a huge pot of flowers that we had sent to

the invalid as an expression of our sympathy, the door was at first shut in his face. He was taken for a hawker of flowers!

∴

Somewhere I have seen a rough and ready rule described for getting the sun and moon of a proper size in pictures and drawings and photos. Does any one know it? Frequently in photographs where the sky has been put in afterwards, the toucher-up will put the sun or moon in too small, giving an absurd effect.

∴

Also where have I seen it stated that Gainsborough was at one time so fond of painting warm red shadows to his portraits, even where they did not exist, that he employed red shades to his lamp to get the effect. Is this at all likely?

Now that the artist has left us, I feel no compunction in reminding myself of an extremely flagrant instance of copying from our library books, an instance so open that it is difficult to understand why it was ever perpetrated. One of the numbers of the *American Art Amateur* gave a coloured print of some tapestry, the subject being a somewhat queerly drawn sea nymph. Now this nymph was copied straightway without any modification onto one of the Doulton Vases. The subject was, in its way, so characteristic that it would be remembered by anyone once seeing it. Consequently wherever that vase is shewn, it is sure to be recognised and the cheat spoken about. I admit that I do steal ideas myself but wholesale purloining such as this would be too much for my conscience. I imagine

that the books in the library are
not for copying from, but for hints
and models of work. Our products
are expensive and can only be pur-
chased by people of means — people
who are sure to see the art magazines
and who would be quick to recognise
any appropriation therefrom, and
value accordingly the remainder
of our work. That is to say, they would
see some of the most expensive of our
pieces with borrowed subjects on
them, and would conclude that the
rest of the work had all been copied
from objects they did not happen to
know. Surely then for our reputation
as well as for conscience's sake this
copying should be sternly discour-
aged. Does it not seem reasonable
to say that a figure-artist who
cannot design his own figure subjects
but has to copy them, should not

be doing figure-work at all? If the work is not to be original, let it not be begun.

∴

Scene. The Showroom. Enter Stranger, evidently wealthy. Rush of attendants to shew him round. He displays a disposition to buy and selects some Doulton & Barlow Ware. Then looks at Faience.

Attendant (eagerly). "Here is a pair of Pilgrim Vases, painted by one of our best artists. It is —"

Stranger. "By one of your artists, Eh? Who is he? What's his name?"

A. (has to look at bottom of vase and scratch several labels off)

S. "Oh never mind. How long has that been on show? A few years, eh? I thought so, and don't wonder at it. Do you know (I don't suppose you do, though) that those paintings are

copied, and badly copied too. The drawing is something horrible. Now I happen to own the original of that. It's a Jules Breton — never heard of him, I dare say. The other is a hashup of Millet — not your Millais, you know, but the other one. You had better turn those vases with their face to the wall, or better still, smash them. You'll never sell them. What d'yer mean by showing me such stuff? Well I never! Your painters are cute, and no mistake. Why that plaque is copied from a Japanese drawing, only you have done it upside down." (Turns to go out).

Attendant. "But sir, the Doulton Ware!"

Stranger. "I don't want your Doulton Ware. I daresay it's all copied!"

A. "But the Barlow ware!"

S. "Seen it all before. Have lots of it in America. All copied!" (Exit).

Starkie Gardner & Co have very happily introduced some Doulton Ware flower pots into their wrought iron screen at the C & J. Exhibition. I wonder if the ecclesiastical art metal-workers could use Doulton ware in bosses and rolls and other little decorative enrichments.

∴

Why should our artists resent the intrusion of visitors? I read that Canova's studio was open at all hours to the public, for it pleased him to hear everyone's criticisms, saying "that a chance word had often given him a new idea or a fresh turn to a thought"

∴

To mend china. Into a solution of gum arabic stir plaster of paris until the mixture assumes the consistency of cream; apply with a brush. In 3 days the article cannot be broken in the same place. (Pottery Gazette).

What is the meaning of a "Winchester quart"? I read that Edgar the Saxon King (958) established a uniform coinage and weights & measures taking their name from Winchester, and that the "Winchester measure" (a bushel of thirty one quarts) was only abolished as recently as George the 4th.

∵

Matrimony is in the air.

∵

Mr Parker's Gold Medal is the first that has ever come to Lambeth for a modelled design. Hurray!

∵

There is just room to mention that the prizewinners at the Lambeth Sketch Club for the last session were in "figure" 1st. Miss Nicolls ; 2nd, Mr Finberg ; 3rd Miss Lilley ; and in "Landscape":—

W.G.

(When are the prizes coming?)

Corner of No 92 Room

The Corner of No. 92 Room
(Sketched some years ago)

*Sketch by Walter Gandy of the new Lambeth Headquarters
under construction June, 1887*

Rules

A copy of the 'Rules' drawn up by Walter Gandy
governing the distribution of Studio Notes

THE AUTHOR

Peter Rose F.S.A., formerly Head of Combined Arts at Brighton University, is a writer, lecturer and collector. His interest in the nineteenth century, particularly the Design Reform movement, was first stimulated by examples of the salt-glazed pottery of Henry Doulton & Co. He worked closely with American collectors, Allen Harriman and Edward Judd and in 1982 they published his research in *George Tinworth*, a record of his life and work. In 1985, Peter wrote *Hannah Barlow, A Doulton Artist*. He has also written many articles on Doulton pottery including regular contributions to the Royal Doulton International Collectors Club magazine. He is a committee member of the Decorative Arts Society and served a term as its chairman making regular contributions to its annual journal. He has also co-authored or made substantial contributions to various Arts and Crafts publications including *Whitefriars Glass* and, most recently, *W.A.S. Benson: Luminary of Design*.